A Portrait Album

of

Four Great Rhode Island Leaders

by
Marguerite Appleton, Ph.D.

Published in cooperation with
The National Society of the Colonial Dames of America
by
The Rhode Island Historical Society
Providence, Rhode Island
1978

Copyright © The Rhode Island Historical Society 1978
All rights reserved
Printed in U.S.A.
Library of Congress Catalog Card Number: 78-65086
ISBN Number: 0-932840-00-0

No part of this publication may be reproduced or transmitted in any form or by any means, electronic or mechanical, including photocopying, recording, or any information storage or retrieval system without permission in writing from the publisher, except by a reviewer who wishes to quote brief passages for a review to be included in a magazine, newspaper, or broadcast.

Set in Baskerville type.

To
My Father
Who passed on to me his love of History

Contents

Foreword ... ix
Preface .. xi
Portraits
 Roger Williams 3
 Stephen Hopkins 31
 John Howland 63
 Elizabeth Buffum Chace 89
Conclusion 117
Index .. 119

Illustrations

 Roger Williams 2
 Stephen Hopkins 30
 John Howland 62
 Elizabeth Buffum Chace 88

Foreword

Although they lived in different centuries, the four subjects of the following portraits had a number of things in common. Chief among these were their commitment to liberty and their sense of civic duty. Roger Williams, Stephen Hopkins, John Howland, and Elizabeth Buffum Chace form an interesting family portrait for Rhode Island.

Of them all, Roger Williams is perhaps the best known to the national audience. An outcast for his holding of unpopular and threatening beliefs about the individual's right to heed the dictates of his own conscience against the rules of the magistrate and preachings of the puritan divines, his concept of "soul liberty" and separation of church and state became a bedrock foundation stone in the building of the American republic. It seems ironical that such an outcast and individualist would be called upon to form a community, but he did. Williams and other separatists like Anne Hutchinson, Samuel Gorton, and John Clarke struggled against their inward natures and strong external foes to establish the colony of Rhode Island.

Stephen Hopkins's life was devoted to civic duties from offices in the town meeting to the attorney generalship and office of governor of the state. A fierce opponent of tyranny, his revolutionary pamphlets and his duties in the Continental Congress qualified him for the title of a founding father.

Another participant in the struggle for American Independence was John Howland, although his greatest contribution to his community was the establishment of the public school system. Howland led the campaign in Providence to extend freedom by providing everyone access to a public education. No philosopher or partrician-philanthropist, he was a master barber. His

shop was a salon in the eighteenth century sense of the word, an informal, congenial place for the exchange of great ideas — not the politician's backroom, but the public's front porch for the discussion of civic improvements.

Elizabeth Buffum Chace spent her life promoting the extension of freedom: in the fields of antislavery, suffrage for women, and the liberation, as she saw it, of many from the bondage of alcohol. She sought to introduce humanity and rehabilitation into Rhode Island's treatment of the poor, the criminal, and the insane.

The Rhode Island Historical Society is pleased to have the opportunity of transmitting the story of these four lives. We are equally pleased to have as our author for the work our good friend and member, Dr. Marguerite Appleton who has spent her life lecturing in the Providence area on the themes and incidents of Rhode Island history. The society is indebted to the National Society of Colonial Dames of America for their financial support to make this work possible, particularly to the National Historical Activities Committee and its Chairman Mrs. George C. Denniston. We have had a long and pleasant association with the Colonial Dames of Rhode Island and greatly admire and respect their stewardship of two of our best historic properties, the Stephen Hopkins House in Providence and the home of George Berkeley, Whitehall, in Middletown.

We are also indebted to Providence Mayor Vincent A. Cianci and his assistant Dr. Carl Stenberg for their initial support and encouragement. We trust the examples of unselfish civic duty portrayed by the subjects of the book will pay a dividend to the city.

Lastly, we are grateful for the editing and publishing skills of the Veritas partnership, Glenn LaFantasie and Paul Campbell, who saw the book through the press for us.

Providence
September 1, 1978

Albert T. Klyberg
Director

Preface

During the Bicentennial year, we were filled with pride about the part played by our ancestors in establishing independence and the federal union. Now that the celebrations are over, we should not forget, in spite of the pressures of today's problems, the contributions of Rhode Island leaders who built the strong and successful state which we have inherited. Four Rhode Islanders seem to stand out in the history of our state, and it seems fitting to pay tribute to them and to their contributions to Rhode Island.

No attempt has been made to write detailed biographies. Rather each is a "Portrait" of an individual, and it is hoped that each stands out as clearly against the background of his or her period as any oil portrait painted in rich and glowing colors.

One of the most enjoyable tasks of writing is that of expressing appreciation for the help one receives. I wish to thank the members of the staff of the Providence Athenaeum for their constant help in securing for me many books, tucked away here and there—sometimes on high shelves. I am also grateful for help of the members of the staff of The Rhode Island Historical Society when I visited them in the same quest for special material. My heartfelt thanks goes to the members of the National Society of the Colonial Dames of America for their interest in my book, and for the very generous contribution towards the expenses of publication. And words cannot adequately express my thanks to Miss Margaret B. Stillwell, herself a most successful writer, for her help in the preparation of my manuscript, and her interest in this, my "magnum opus."

<div style="text-align: right;">Marguerite Appleton</div>

A Portrait Album

Roger Williams

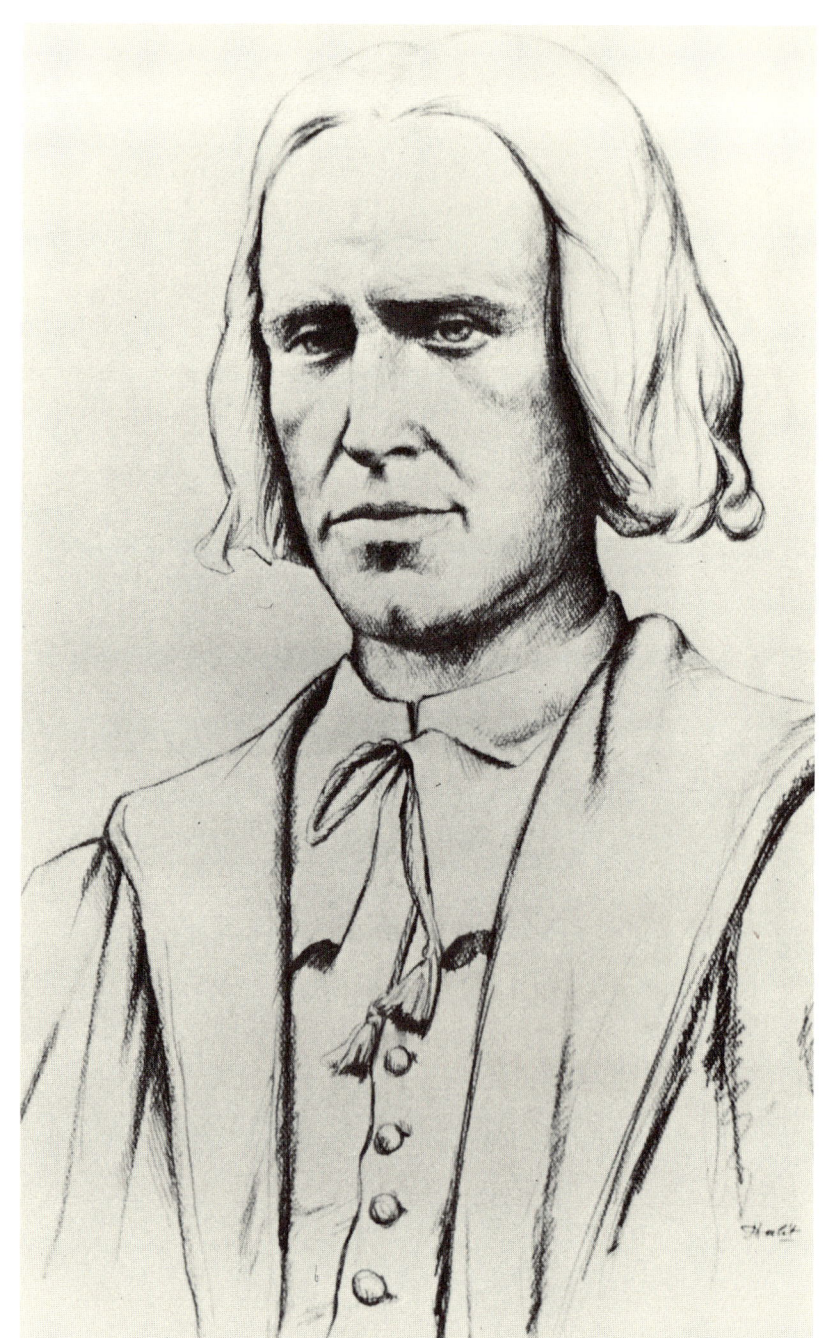

Roger Williams

On February 3, 1631, the good ship *Lyon,* filled with twenty colonists from England, arrived in Nantasket, Massachusetts. No doubt the passengers crowded the rail to catch their first sight of the New World, and none of them could have been more eager than Roger Williams and his wife who were seeking in New England that freedom of conscience, "soul liberty" as he called it, which no longer existed in old England. It must have been an awesome moment as the boat approached the shore, for Williams knew that he would meet many of his old friends, and he felt sure that he could live happily for the rest of his life in New England.

Roger Williams was born, probably in London, in 1603 and grew up in a period of religious and political strife when the Stuart kings were trying to assert complete control over Parliament, forcing Englishmen to conform to the rituals and practices of the Church of England. Even before the reign of the first Stuart king, James I, there had developed strong sentiment—the Puritan movement—against some practices of the Church of England, and the attitude of the Stuarts toward Parliament added fuel to the flames which produced the long drawn out struggle between the monarch and Parliament.

It was natural that during Williams's boyhood he would hear discussion of the many angles of these two great questions over and over again and would ponder on them in his heart. Of his schooling, we know little but as a teenager he was fortunate in attracting the attention of the great jurist, Sir Edward Coke, Lord Chief Justice, and the most brilliant lawyer of the century. Their acquaintance grew into friendship, and it was through Coke's patronage that Williams became a student in Charter House School which prepared him for Pem-

broke College, Cambridge University. His four years at college, two as an undergraduate, and two years working for a degree in Divinity, proved to be one of the major influences in his life, for Cambridge was far more liberal in its teaching and its philosophy than Oxford. Then, too, the same question of church and state, which was being debated all over England, was at the boiling point at the university. Williams became a very liberal thinker, and throughout his life he sought the true religion that men could live by. Consequently, he believed without question in the individual's right to worship God as he desired, and he believed also in the separation of church and state.

Williams was somewhat older than most students when he received his Bachelor of Arts degree in 1627, but he stayed on two years longer, taking Holy Orders in 1629. The young scholar then became a chaplain in the home of Sir William Masham in Otes, Essex. Happy years they were for the most part, and important years, for Robert Rich, second Earl of Warwick, was an associate of Masham, and he proved a very helpful friend to Williams several years later when he was seeking a charter for his little colony in Rhode Island. While serving as chaplain, Williams married Mary Barnhard who proved to be a good wife to him.

Williams knew about the plans of the members of Massachusetts Bay Colony to leave England and settle in the New World, but for some reason he decided not to go with this group. It was two years later that he came to the conclusion that he could no longer endure the unhappy conditions in England and took passage on the *Lyon*. Welcomed in Boston, he was invited to preach in the Boston Church, but he declined because he was a "Separatist" and Massachusetts Colony was not. Moreover, Williams soon discovered that the Bay Colony had set up a tight theocratic state in which the leaders of the church were also the political leaders of the

colony and conformity was a must. His philosophy about the right of the individual to worship God as he wished was treated with distrust and displeasure.

For five restless years Williams lived in the Bay Colony. They were years of increasing frustration and unhappiness on the part of both Massachusetts Bay leaders and himself. Now and again he preached in Salem and was well liked there, even though the Boston churchmen were opposed to him and his principles. For two years he resided in Plymouth where he found peace and friendship among the people of this little settlement. Not only were they more liberal in their thinking, and therefore accepted Williams in spite of his radical ideas, but he had time, perhaps, to consider his future in New England. He also had time to learn the art of farming which was to stand him in good stead as long as he lived. And finally, it was during his stay in Plymouth that he became acquainted with the Narragansett Indians. He became deeply interested in the natives of southern New England, their customs and their habits of thought. It was then that he made the solemn decision to become a missionary to the Indians; a decision which he never forgot, and one that colored the whole of his life.

In 1633 he was recalled to Salem and installed as the regular preacher. He held this post for about two years. By this time, Williams was definitely *persona non grata* in the Bay Colony. He had been very outspoken against the integrated church and state there and opposed their policy of extending the franchise only to church members. And as if this were not enough, he had sharply criticized the Massachusetts colonists for appropriating the land for settlement without adequately paying the Indians.

Finally, in the fall of 1635, the leaders of the Bay Colony decided to get rid of him, and after a wearisome trial Williams was ordered to leave. But because of the

harshness of the New England winters the edict was softened a little by permitting him to stay until spring, provided that he kept his controversial ideas to himself. This, Williams refused to do. Although he was fundamentally kind, he could not refrain from expressing himself boldly on matters he did not approve of. The Bay Colony leaders, their patience strained to the breaking point, decided in January 1636 to arrest him and ship him back to England.

By chance Williams heard of this change of plan before it could be carried out. Leaving his wife and child behind he slipped out alone on a winter night. For fourteen weeks he wandered here and there, looking for a place to settle. He would have perished except for the friendliness of the Indians who gave him food and shelter.[1] In April he reached the territory of Plymouth Colony, and thought that, at last, he had found freedom and safety.

By this time four other men had joined the banished minister. They had been members of Williams's Salem congregation, and like him, were dissatisfied with the policies of Massachusetts Bay Colony.[2] At first the future seemed bright, but in June Plymouth Colony officials informed Williams that, though its leaders did not object to him and his beliefs, still they were unwilling to anger the ruling elders of their neighbor, the Bay Colony. Consequently, he was told that he could not settle within the boundaries of Plymouth Colony. This must have been a bitter disappointment to Williams and the others, because they had already planted some crops, and they meant to stay there permanently. Such a message, however, could not be questioned; they abandoned their crops and started out once more in search of a home beyond the needling criticism of Massachusetts.

Acting on the advice of Governor Winslow of Plymouth, the little band turned towards the west, and

finally reached Seekonk, now the town of Rehoboth. From there Williams, and one young man, Thomas Angell,[3] paddled across the Seekonk River and landed—so tradition tells us—at Slate Rock where they were hailed by friendly Indians, who greeted them with "What Cheer, Netop!" Still the two men pushed further along down the river and around a neck of land, now called Fox Point. There, they discovered another river, the Providence River, and turned their canoe north.

It was not long before they sighted a high thickly wooded hill on the eastern shore (College Hill) that they were sure would provide game and also lumber for their houses, as well as serving as some shelter from the bitter New England storms. On the western side of the river a flat plain seemed to stretch as far as the eye could see, and this could be used to pasture their cattle. When the two men finally found a spring of fresh water at the junction of two rivers—the Moshassuck and the Woonasquatucket—their joy must have been boundless, for without fresh water they could not survive. We can imagine the two explorers, after landing near the spring, kneeling down to thank God for His goodness in leading them to this spot. So conscious was Williams of God's care and protection during his long weeks of wandering, "God's Providence," he called it, that he named his new home "Providence."

Either just before or shortly after his expedition with Thomas Angell, and his decision that the land at the mouth of the Moshassuck and Woonasquatucket rivers was a good place for a settlement, he secured some land from Canonicus and Miantonomi, the chief sachems of the Narragansett Indians. It was known as the "Purchase," although Williams asserted that he had never paid for the property in actual cash.[4] It was a generous tract stretching in a sort of triangle from the Pawtucket Falls on the northeast and along the banks of the Seekonk River to Neutaconicut Hill on the west, and

thence south, southeast to the Pawtuxet River. This grant to Williams was confirmed by Canonicus and Miantonomi in March 1638.[5]

The northeastern section, later called "the Neck," became the heart of the little community, and here the settlers built their homes on what they called Towne Street along the Providence River. In 1638, Williams divided the Neck in equal shares with twelve settlers, his "loving friends and neighbors." When they were able to build permanent homes, naturally they built in the style they had been used to in England. The first houses, however, consisted of one room with an end chimney. The floors were of earth, and the walls were built of vertical planks plastered with mud, while bark or thatch covered the roofs, insuring perhaps a little more warmth. These little houses were eventually enlarged, and the rude chimneys of logs were replaced by stone chimneys.[6]

In the beginning, there were so few "loving friends and neighbors" living in the tiny settlement that the simplest kind of government sufficed. This consisted of the heads of families who met together about once every two weeks to maintain order and decide on matters of general interest. Williams, however, was already thinking ahead. He had his own ideas about the kind of government he intended to have in his colony. Without question, he would establish freedom of conscience, and he thought well of the workings of the town meeting as he knew it in the Plymouth and Bay colonies. He drafted two documents to serve as a blueprint. The first designated the heads of families of the original group as the heads of the colony with power to conduct the business of the colony, and the franchise automatically extended to them. A second document provided for newcomers as citizens, but they were not allowed the privilege of the franchise, or a voice in the government.[7]

Meanwhile, during the first summer the arduous

labor of house building and trying to provide against the winter months had hardly begun before the Massachusetts colonists urgently called on Williams for help against the Indians. A serious emergency had arisen following the murder by some Pequots of John Oldham, a trader with the Indians, who had been greatly respected by both the natives and the English. The Pequots were the most warlike tribe in New England and bitterly hated the whites. As this murder was not the first committed by members of this tribe in and around Connecticut, the Massachusetts leaders decided that the time had come to punish the Pequots. Accordingly an expedition was sent against them, and some of their canoes were destroyed, and wigwams burned. Now, angrier than ever, the Pequots tried to persuade their former enemies, the Narragansetts, to join with them to exterminate the English colonists. The consequences of a Pequot-Narragansett alliance against the English were too horrible to contemplate, and Massachusetts turned to Williams as the one man who could save the white settlements from destruction.

Williams set out at once in a canoe down Narragansett Bay to the "Great City" to confer with Canonicus, and by good luck arrived before any agreement had been concluded. He stayed three days with Canonicus, and his friendship with the Narragansetts and their trust in him prevailed. Williams succeeded in preventing the alliance.[8] Nor was this all he accomplished. During those three days he persuaded the Narragansetts to make an alliance with the Mohegans against the Pequots. This was one of the most important contributions of Williams's life and work, and there can be little doubt that he saved New England for the white settlers. A few months later another Massachusetts expedition against the Pequots at Fort Mystic at the mouth of the Mystic River overwhelmingly defeated the Indians, and the few survivors were at length sold into slavery or par-

celed out to other Indian tribes.

Williams's prestige as the key man between the Indians and the whites continued to grow. Due to his care and in spite of difficulties that cropped up from time to time, peace continued in New England for over a generation. His work with the Indians developed into one of the major interests and activities of his life. His home was always open to the red men and they consulted with him frequently. He always seemed to know what was going on among the various tribes; he knew their problems, their joys and their sorrows, their difficulties in their totally unforeseen situation of living as neighbors with the English strangers. It is, indeed, not too much to say that it was Roger Williams who held the security of New England in the hollow of his hand for forty years.

The infant community in Providence experienced three important events in 1638. The first of these was the organization by Williams and his neighbors of the Baptist church, the Mother Church of all Baptist churches in America. For well over fifty years this group worshiped under the trees in summer and in each others' houses in winter. The second event—no doubt celebrated with thanksgiving—was the birth of the first boy in the colony, a son to Williams who named him, appropriately enough, "Providence." The third was the coming of Anne Hutchinson and her followers to settle in Rhode Island.

Mrs. Hutchinson was so much beloved that when she was banned as a heretic by the leaders of the Bay Colony, thirty families gave up their homes and left with her. The members of this group had first decided to go to New York, which was much more liberal in its attitude on religious questions than Massachusetts, but they were so impressed by the beauty of the island of Rhode Island in Narragansett Bay that they decided to settle there. Through the good offices of Williams, they

bought the land from the Indians and settled in Aquidneck (Portsmouth).[9] William Coddington, a leader in Boston, had been converted to Mistress Hutchinson's religious doctrines and had come with her to the island settlement. A year later Coddington and nine other families moved down to the southern tip of the island and founded Newport.

In 1642, Samuel Gorton, that truculent and aggressive individual who found it difficult to live with any neighbors, made his home in Warwick. Now Providence was no longer a lonely outpost of white civilization in the Indian country.

Yet the Rhode Island settlers were mere squatters on the land, for they had no charter or legal document of any kind from the English government which recognized the colony as a part of the Empire, and accorded its members the rights of Englishmen. True, they thought of themselves as Englishmen and governed themselves in conformity with English law, but this did not take the place of a charter. No one understood the pressing importance of this matter better than Williams. Therefore, sailing in a Dutch ship from New Amsterdam (Massachusetts refused to allow him even to pass through Boston) Williams left for England in 1642 to secure, if possible, a charter.[10] He found his native country on the eve of civil war, but he had many friends there—among them Henry Vane, and the Earl of Warwick.[11] With their help he was granted a charter and returned home in 1644. Williams arrived in Rhode Island by practically the same route as he had when ousted from Massachusetts seven years before, but because he was now armed with a letter of safe conduct, the leaders of the Bay Colony were forced to let him land in Boston en route home.

News of the success of his efforts and his homecoming had been received, and, as he crossed the Seekonk River, he was welcomed by fourteen canoes of cheering

Rhode Islanders. Williams was deeply touched by the welcome, and he must have felt that his "cup runneth over," and that he would never experience a happier day for the rest of life.

The charter itself was brief and rather vague and did not mention Williams's fundamental belief—freedom of the individual to worship God as he desired. It did, however, clearly recognize Rhode Island as a British Colony, granted the settlers the rights and privileges of Englishmen, and also—and this was an important and very unusual privilege—bestowed the right to elect their own officials and govern themselves. As for religious freedom, the colonists believed that since the charter did not expressly forbid it, it had not been denied.[12]

The document recognized Rhode Island as one colony, but it was no easy matter to set it up this way. The four communities were not only geographically separated—two on the island of Rhode Island and two on the main land—but the colonists were fiercely independent in their thinking. Consequently, it took three long years and all of Williams's tact and powers of persuasion to achieve the almost impossible; that of merging the four settlements under a central government. At last this was accomplished, and the first assembly with John Coggeshall as president met in May 1647.[13] Roger Williams was named as one of the assistants. Although Providence was by this time eleven years old, we may call the year 1647 the first birthday of the little colony.

Perhaps Williams thought that with the colony organized and with the possession of a charter, the future was serene and secure, but his labors as arbitrator were not yet finished. There were a few settlers who did not want to give up their identity as four separate communities. Chief among these was William Coddington, the founder of Newport. His Newport had grown much faster than Providence and for some time he had dreamed of setting himself up as governor for life of the

islands of Rhode Island and Conanicut. He had been, therefore, bitterly opposed to Newport and Portsmouth joining with Providence and Warwick under the new government. The more he thought about this, the more he resented it, so in 1652 he went to England on a mission of his own, seeking a charter that would set up the two islands as a separate colony with himself as governor. And he was successful for, like Williams, he had friends in important positions in the government.

Coddington's return in 1652 threw the colony into turmoil. His document not only undid the work of Williams and his colleagues and split the colony into two parts, it also turned the 1643 charter into a piece of waste paper. Something had to be done, and done at once. Immediately Providence and Warwick petitioned Williams to go to England to seek redress from Coddington's infamy. Within a short time, Williams again set sail for England to save the charter of Rhode Island. This time he did not go alone, but had a companion, Dr. John Clarke of Newport, who opposed Coddington's subversive design.

By now the Civil War was over; the triumph of the Puritans was complete, and Oliver Cromwell was Lord Protector of the Commonwealth. Once more Williams applied to the government, and once more he was successful. The 1643 charter was upheld, and Coddington's "charter" was revoked. Some years passed before Coddington was ready to accept defeat, and it must be admitted that he had not a few supporters. In 1656, however, he realized that he had to abandon his plans, and he took the oath to support the central government. Williams had triumphed and disunion was now a thing of the past.

The year 1660 brought a new governmental crisis to the colony. This was the year of the restoration of the Stuarts to the throne of England, and it was obvious that Charles II would not accept as legal the 1643 charter

which had been drawn up by a revolutionary government that had done away with monarchy. This time Williams did not make the long journey to England. He was now middle-aged and had never completely recovered from the results of the rigors of his winter in the wilderness some twenty-four years earlier. He wrote to Dr. John Clarke, who had remained in England, begging him to obtain a charter that would insure the rights of Rhode Island under the new government. Dr. Clarke set about this task immediately and was finally successful.

The Royal Charter, complete with an engraved likeness of Charles II, his signature, and the great seal of the government, arrived in the colony in 1663.[14] It was received with becoming ceremony, and Williams was appointed to represent Providence. Captain Baxter, who had brought the charter from England in his ship, arrived in Newport, opened the royal box and showed the great seal, the royal stamp, and the King's letters to the colonists. Great was the rejoicing, and a holiday was held to mark the event.

The Royal Charter was clear cut and detailed, and confirmed all the rights and privileges of the original charter. In addition, definite boundaries between Rhode Island, Massachusetts, and Connecticut were designated. The precious gift of religious freedom was also included and spelled out in unmistakable terms:

" ... no person within the said colony at any time hereafter shall be any wise molested, punished, disquieted, or called in question for any difference in opinion in matters of religion which do not actually disturb the civil peace of the said colony; but that all and every person and persons may from this time and at all times hereafter fully and freely have and enjoy his and their own judgements and consciences in matters of religious concernment ... they behaving themselves peaceably and quietly and not using this liberty to licen-

tiousness and profaneness, nor to the civil injury or outward disturbance of others . . . "

This was Roger Williams's great and unique contribution to the world. He never forgot the colony's debt to John Clarke in obtaining the charter, and he worked for years to get the towns to repay Clarke for expenses incurred as agent for the colony. Writing to Warwick to contribute its share for Clarke, Williams spoke of the rewards which the document had bestowed on Rhode Island, "such peace, such security, such libertys for the Soul and Body as were never enjoyed by any English men, nor any in the World yet I have heard of."[15]

Unquestionably the Royal Charter was of inestimable value to Rhode Island, as it placed the colony on the same standing as its neighbors, but it produced painful boundary problems with both Connecticut and Massachusetts. The most troublesome question arose over the Narragansett Country, that fertile stretch of land on the west side of Narragansett Bay. For many years both the colony's neighbors had looked on this with greedy eyes and had tried to acquire it for their own settlers. Now in 1663 this section was granted to both Connecticut and Rhode Island.

In its charter Connecticut's eastern boundary was designated as Narragansett Bay, while Rhode Island's western boundary according to its charter was set up as a line drawn from the Pawcatuck River (now Westerly) due north to the Massachusetts' southern border. This meant that both colonies claimed the Narragansett Country. Who was right? Connecticut declared that she was right, for her charter had been issued in 1662. On the other hand, Rhode Island claimed that her charter, issued a year later, abrogated Connecticut's title to the land.

Disputes and quarrels erupted almost immediately, and Williams was appointed on four separate committees to draw up instructions for Rhode Island's repre-

sentatives when they met to discuss terms and settlements. In 1664, a royal commission was sent to America to visit each colony and to make a general survey of conditions in the many communities. This gave Rhode Island an excellent opportunity to ask for help in solving the Connecticut boundary problem, and Williams met with the members of the group. The case was so complex, however, that the royal commissioners decided on a compromise. They took possession of the land in the King's name, calling it "King's Province," and ordered that the magistrates of Rhode Island should be the justices of the peace to maintain law and order.[16] This was perhaps encouraging, but in reality it meant that the controversy was no nearer solution than before.

The dispute with Massachusetts involved the claims of Plymouth, and was in some ways less difficult, but again the 1664 commissioners declined to make a clearcut decision. They decreed that although Narragansett Bay was the natural boundary between Plymouth and Rhode Island, there would be no decision until "His Majesty's pleasure be known."[17] Thus, on both the east and west, Rhode Island was forced to fight again and again to get the boundaries as outlined in her charter, recognized by Connecticut and Massachusetts. As a matter of fact, it was not until long after Williams's death that this was accomplished.

Meanwhile, claims and counterclaims in Pawtuxet produced a long and dreary chapter in the life of the colony and also of Williams. As the years dragged along, it must have seemed to Williams that the angry disputes would never be ironed out. One of the chief protagonists in the land controversy was William Harris. He had been one of the original companions of Williams and later proved to be a troublemaker, creating a Pandora's box of problems for Williams. Harris was a man of considerable mental ability, yet he was a restless and

dissatisfied individual. He never achieved a stable philosophy, either religious or political and embraced one new idea after another, eventually becoming an extreme radical. He had received a lot in Providence in the first division of land, but soon afterwards moved to Pawtuxet, and either by accident or design, settled beyond the territory granted to Williams by the Indians.

In the troubled decade of the fifties he went so far as to declare himself against all government and in favor of complete freedom for the individual. He even attacked Cromwell's government in England. Williams was president of Rhode Island at this time, and he ordered Harris's arrest on a charge of teason. The court decided that Harris's writings were indeed dangerous and that his book and the records of the trial should be sent to Dr. John Clarke, who was serving as the Rhode Island agent in England, so that he could press the case further if in his judgment this was advisable. What would have been the outcome of this, one can only guess for the ship was wrecked and Harris's book and all the papers were lost. The shadow over Harris thus floated away, but after this episode the bitter antagonism between Harris and Williams never subsided.

No sooner had he been freed from the possibility of standing trial in England, the irrepressible Harris plunged into a legal battle over his lands in Pawtuxet. He had been living there for twenty years and had appropriated more and more land for himself, but apparently this had not been questioned until the Rhode Island Assembly in 1659 considered buying some land in that section and clearing out the Indians.[18] Although Harris had always felt secure because he possessed a copy of the original deed from Canonicus and Miantonomi to Williams, he at once took the precaution to bolster his postion by securing three more deeds from the heirs of the two sachems. And he adroitly worded these three deeds to make them seem as if they con-

firmed Williams's confirmatory deed.[19]

The following year he was able to get the town meeting to accept as correct his copy of Williams's original deed, as well as his three new deeds, in spite of the fact that his copy spoke of the Pawtuxet lands *without* the qualifying phrase "for use of cattle."[20] This at once raised the question not only of the exact boundaries of the colonists' holdings, and therefore of the Indian lands, but more important, whether Harris had deliberately interpreted very freely his copy of Williams's deed for his own advantage. Williams declared explicitly more than once that Harris ignored the phrase, "for use of cattle" which Miantonomi had understood, and had intended only as an extra courtesy for the settlers. It definitely did not give the English title to the lands; nevertheless, to his amazement and anger, Harris's deeds were accepted, and it was ordered to have them transcribed in the town records.

It looked as though Harris had won the battle, which would have deprived the Narragansetts of three hundred thousand acres. He now demanded that the boundary between his holdings and the Indian lands be drawn according to his deeds. Much to his wrath Harris could not seem to get this done; somehow the running of the line was delayed again and again. Months and even years went by and still the boundary lines were not run. For one thing, other events sometimes shouldered Harris's project into the background, and although he appealed to King Charles for help, success always seemed to elude him. In reality, the delay was due in large measure to the determination of Williams that Harris's nefarious schemes should not win out. Williams was no friend of Harris; he was a friend of the Indians. He had lived with the Narragansetts, had worked with them and for them, had traded with them honestly and squarely for over twenty-five years, and he had no intention of seeing them defrauded of three hundred

thousand acres of land.[21]

After Rhode Island recovered in part from King Philip's War, the question of Harris's claims and the boundaries of Pawtuxet were revived. The case was retried in 1678 by a commission on order from the royal government, and once more the verdict was in Harris's favor. He was permitted to keep his lands. Still the ever important boundary lines had not been designated, and therefore his land still was not officially delineated.

In 1679, he made the long journey to England to lay his case before the King, but now fate stepped in. On his way across the ocean his ship was captured by Barbary pirates, and he was sold into slavery. After a year in the galleys he was ransomed, but this time he never recovered from his ordeal and in 1680 he died in England. At last Roger Williams was relieved of his "forty years of vinegar."

Nothing demonstrates the unquenchable spirit of Williams better than his encounter with three Quaker missionaries in 1672. The Quakers had settled in Newport some twenty years earlier. There they found rest for their bodies and souls which had been denied them elsewhere. Although Williams never for one instant swerved from his conviction of the right of the individual to worship God according to the dictates of his conscience, he didn't really like the Quakers. He could not bring himself to accept their doctrine of the guidance of the "inner Light" which he felt belittled the teachings of Jesus. In addition, several members of the sect were zealous to the point of fanaticism and had been responsible for considerable unrest and even in some cases for out and out civil disobedience after their arrival in the colony.

When, therefore, he heard that George Fox, the founder of the Quakers, was in Newport, he determined to call on him for a debate on the fundamental doctrines of the Quaker faith. Williams believed that he

was well prepared for such a confrontation, for over the years he had studied Quaker literature with care, and furthermore, he had learned the art of debate during his undergraduate days at Cambridge University. He prepared a list of fourteen "propositions" that he wished to discuss with Fox, and sent them to him in the summer of 1672. The story that has come down to us is that the Newport Quakers, who had little love for Williams, not only did not deliver his challenge to Fox, but allowed him to leave town before Williams arrived.

Nevertheless, four debates—three in Newport and one in Providence—took place between Roger Williams and three Quaker missionaries who had not left with Fox. He did not have an easy time. No one had been appointed to serve as a presiding officer and Williams was heckled and interrupted over and over again; moreover, his adversaries turned out to be no mean opponents. Williams spoke first all day long on his first "proposition," that "the people called Quakers are not true Quakers according to Holy Scripture."[22]

Although he was very weary after the first day, for he had rowed from Providence to Newport the day before, the oratorical contest continued for two days longer, and still there seemed so much to be said on both sides of the question that the debate was adjourned. About a week later in Providence the two contestants met again and finally completed the dispute over the fourteen "propositions." Williams's great "crusade" against the Quakers was over.

Neither side won this historic debate, because neither would concede victory to the other, but undoubtedly Williams felt confident that he had exposed the heresies and weaknesses of the Quaker teachings. He continued the war in print by writing a long account of the incident in which he included all his charges against the Quakers. He entitled the book, *George Fox Digged out of his Burrowes*.[23] Although this was written soon after that

memorable summer, it was not printed until after King Philip's War.

Not to be outdone, George Fox replied to the attack by writing a book which he called *The New England Firebrand Quenched*.[24] Evidently Fox had writhed under Williams's criticism of a previous book which Fox had published, as well as his broadsides in the debate. He launched a bitter assault on Williams, and indulged in unbridled invective, calling him a liar over and over again as well as accusing him of being "malicious," "evasive," "ignorant," "impudent," and a score of other unpleasant qualities.

By 1673, the peace with the Indians which had been established after the Pequot War, and which had been maintained largely through Williams's efforts for forty years, began to deteriorate. By degrees the relationship between the Indians and the whites worsened. Williams understood this, and the Bay colonists knew it, but somehow little could be done to improve the situation.

Then disaster struck in 1675, and King Philip's War swept like a tidal wave over New England. King Philip, the sachem of the Wampanoags, had accused Massachusetts Bay Colony of murdering his brother, Alexander, some years before, and the young sachem had sworn vengeance. By selling some of his lands to the English he had been able to acquire arms and supplies of all kinds and also had succeeded in making a partnership with two of his neighbors, Weetamo, the widow of Alexander, who was squaw sachem of an Indian band in Pocasset, and Awashonks who ruled in Little Compton. In 1675, the Wampanoags attacked some white settlements in Plymouth Colony and along the Connecticut River.

At first, the Narragansetts did not join King Philip, but at length even the friendship between Williams and his red neighbors broke down, and they went on the warpath and attacked Rhode Island. Most of the Provi-

dence settlers fled to Newport and so escaped with their lives, but Warwick was burned on March 17, 1676 and Providence about a week later.[25] The efforts of a small band of men, the "eighteen who stayed and went not away," and the struggle of Williams, who had been appointed captain of this group, to save the community were in vain. His anguish must have been overwhelming as he saw Providence go up in flames, and discovered later that only a handful of houses were left standing after the holocaust.

King Philip's War was of short duration, as far as time goes. The Indians were defeated in "The Great Swamp Fight" in December 1675, and six months later King Philip was murdered near his hideout not far from Bristol. For Rhode Island the struggle had not been very costly in the loss of human life, but the destruction of property was immense; the labor of forty years was destroyed in a few months' time.

With tremendous courage the citizens of Providence returned and began to rebuild their homes. At a town meeting held "under a tree by ye waterside"[26] Williams was elected Town Clerk and also a member of the Town Council to reorganize the town government. He was also given the extra duty of settling the fate of the Indian captives. By degrees, Providence began to come alive again, and once more Towne Street became a street of homes and of families living close together, of children running up and down in the sunshine, and of neighbors greeting each other as they went about the day's work.

Although his life was filled with incessant activity, Williams wrote a surprising number of personal letters, many pamphlets, and he was the author of four books. Of these, three were very important. The first was *A Key into the Language of America* which had been in preparation for several years, and was completed during his voyage to England in 1642.[28] It was printed the follow-

ing year by Gregory Dexter who later came to New England and made his home in Providence. The *Key* was not only a vocabulary and phrase book of the Indian languages, but included some of his reminiscences of his dealings with the Indians, and also a dissertation on several aspects of Indian life, such as a description of Indian dwellings and their religion. It added greatly to his prestige in England, for the *Key* was among the first books on the Indians that had been printed since the English had begun to colonize the New World, and it proved to be invaluable for all who came in contact with the aboriginals.

The second book, *The Bloudy Tenent of Persecution for Cause of Conscience,* which he wrote during his stay in England in 1642, expressed in no uncertain terms his unchanging belief in the sacred right of personal religious freedom, "soul liberty," and also the fundamental principle of the separation of church and state.[29] The great problem of church and state had not yet been solved in England, and *The Bloudy Tenent* was addressed to Parliament, and also to the general public.

For us today, the book is hard reading, but through it all shines the core of his understanding of the truth as he saw it. His attack on religious persecution and his straightforward statement that the civil government really had no jurisdiction over the religious life of the individual infuriated both the members of Parliament and also the clergy of all denominations, for religious intolerance was still almost universal. The book was publicly burned in Parliament in 1644, but its boldness gave it wide appeal, and it became for a time almost a "Best Seller." The third book, and Williams's last one, *George Fox Digged out of His Burrowes,* has already been mentioned. How many readers agreed with Williams, of course, can never be ascertained, but one reason for its interest would probably be that in the seventeenth century religion in all its aspects was of tremendous im-

portance.

As the leader of the tiny group which first settled in Providence, and as the founder of the colony, Williams was, of course, the most important man in the community. The government which was set up in 1638 was modeled on his ideas, and from that day hardly a week passed that he was not serving Rhode Island in one capacity or another. The list of public offices he held is a long and impressive one. He was moderator of town meetings, sometimes four or five times a year, and commissioner for Providence repeatedly; assistant, times without number; deputy president, and president of the colony again and again. As for serving on committees—and as often as not he was the chairman—it seems as though little could be done without his help and advice.

He played an important role in the reorganization of the government under the terms of the Royal Charter, was chairman of the committee to set up the government of Block Island which had been granted to Rhode Island, and was a member of the committee to revise the laws and codify them in accordance with the charter. And last but by no means least, he was asked to transcribe the charter for general use while the precious original document was stowed away for safe keeping. In addition, from time to time he served as circuit judge in the justice court, surveyor of public lands, and collector of rates. And as if this were not enough, he drew up petitions, wrote instructions of one kind and another, acted as arbitrator in land disputes within the colony, and the boundary disputes with Connecticut, and with Plymouth. And always he was the mediator between the Indians and the whites.

Although not a young man by any means, during King Philip's War he served as captain of a train band and also helped to evacuate the women and children from Providence. When peace settled over the colony

once more, he immediately began to set up the government of Providence, and helped rebuild as far as possible peace between the remnants of Indians and the Rhode Islanders. His was a life of constant activity and devotion to the welfare of his beloved colony, yet he never failed to refresh his soul by the daily reading of the Gospel.

Roger Williams died in 1683, and his "loving friends and neighbors" gathered around as he was buried in his home lot, while a train band fired a volley across the grave. He had lived a full life; had lived to see the countryside where he and his one companion, Thomas Angell, had decided would be a suitable place for a settlement for the white man grow into a thriving community. He had carried his colony's responsibilities and burdens in peace and war; had preached to his fellow citizens the truths he so deeply believed in. He had taught his neighbors to live in peace with the Indians, and in turn he had taught the natives how to accept the strange ways of the whites. Kindly, generous in spirit, unswerving in his devotion to his God, and to his people, and ever holding aloft the glowing torch of religious freedom, Roger Williams takes his place among the great leaders of all time.

Notes

1. Letter of Roger Williams to Major Mason: "... I was sorely tried for fourteen weeks in a bitter winter season not knowing what bread or bed did mean" *The Complete Writings of Roger Williams,* VI, 335. He later spoke of the "filthy wigwams of the Indians."
2. The original companions of Williams were William Harris, John Smith, Francis Wickes, and Thomas Angell.
3. It is not known just how many men accompanied Williams across the Seekonk River and landed at Slate Rock, and later reached the junction of the Moshassuck and Woonasquatucket rivers. Howard Chapin in his *Documentary History of Rhode Island,* I, 18, quotes an account by Theodore Foster: ". . . Thomas Angell, one of the first settlers and a Purchaser of Providence, when a young lad belonging and living in the family of Roger Williams . . . came with him, the said Williams, in a canoe down the Seekonk River in Mr. Williams' first visit to the Indians settled at Mashasuck . . . No other Person except the said Thomas Angell being then in company with him . . ."
4. "I spared no cost towards them, and in Gifts to Ousemaquin, yea and to all his, and to Canonicus & his, tokens and presents many years before I came in person to the Nahiganset, and therefore when I came I was always welcome" *Ibid.,* I, 24.
5. *Ibid.,* I, 100.
6. John H. Cady, *Civic and Architectural Development of Providence, 1636-1950,* p. 8.
7. Chapin, *Documentary History,* I, 32.
8. *Complete Writings of Roger Williams,* VI, 335.
9. Chapin, *Documentary History,* II, 25.
10. Samuel G. Arnold, *History of the State of Rhode Island and Providence Plantations,* I, 113.
11. At this time the Earl of Warwick was governor in chief and Lord High Admiral of the colonies.
12. The original charter is no longer in existence. Chapin, *Documentary History,* I, 217, quotes one copy which is in the Public Records Office, London.
13. John R. Bartlett, ed., *Records of the Colony of Rhode Island and Providence Plantations,* I, 148. Hereafter cited as *Rhode Island Colonial Records.*
14. The original Royal Charter of 1663, is in the State House, Providence, Rhode Island.
15. Horatio Rogers and Edward Field, eds., *The Early Records of the Town of Providence,* XV, 151.
16. John Carter Brown Manuscripts, I, #63.
17. Calendar of State Papers, 1665, #1103.

18. *Rhode Island Colonial Records,* I, 418.
19. *Ibid.,* I, 2.
20. Chapin, *Documentary History,* I, 61.
21. Williams states: ". . . Pawtuxet I parted with at a small addition to Providence (for then that monstrousbound or business of upstream without limits was not thought of)." *Ibid.,* I, 101.
22. *George Fox Digged out Of His Burrowes,* Narragansett Club Publications, Vol. VI, edited by J. L. Diman.
23. *Op. cit.*
24. George Fox, *The New England Firebrand Quenched,* was published in London in 1679.
25. Arnold, *History of Rhode Island,* I, 409.
26. James E. Ernst, *Roger Williams: New England's Firebrand,* p. 523.
27. Arnold, *History of Rhode Island,* I, 419.
28. Roger Williams, "A Key into the Language of America," published in *The Complete Writings of Roger Williams,* volume 1.
29. Roger Williams, "The Bloudy Tenet of Persecution for Cause of Conscience," published in *The Complete Writings of Roger Williams,* volume IV.

Bibliography

Primary Material

Bartlett, John R. ed. *Records of the Colony of Rhode Island and Providence Plantations.* 10 vols. A.C. Greene, 1856-65. Vol. 1.

John Carter Brown Transcripts, #27.

Calendar of State Papers. Colonial Series, 1664, 3717.

Chapin, Howard M., ed. *Documentary History of Rhode Island.* 2 vols. Preston & Rounds, 1916-19.

The Complete Writings of Roger Williams. 6 vols. Russell and Russell, 1963.

Fox, George. *The New England Firebrand Quenched,* London, 1679.

Secondary Material

Arnold, Samuel Greene. *History of the State of Rhode Island and Providence Plantations.* 2 vols. D. Appleton and Company, 1859.

Bruckneir, Samuel H. *The Irrepressible Democrat, Roger Williams.* Ronald Press, 1940.

Cady, John H. *The Architectural and Civic Development of Providence, 1636-1950.* Ackerman Standard Press, 1957.

Ernst, James. *Roger Williams, The New England Firebrand.* Macmillan Company, 1932.

Garrett, John. *Roger Williams, Witness Beyond Christendom.* Macmillan Company, 1970.

Richman, Irving B. *Rhode Island, Its Making and Its Meaning.* G. T. Putnam & Sons, 1902.

Winslow, Ola E. *Master Roger Williams.* Macmillan Company, 1957.

A Portrait Album

Stephen Hopkins

Stephen Hopkins

Stephen Hopkins, Rhode Island statesman and patriot, was born on his grandfather's farm on March 7, 1707. Son of quiet, hardworking parents, who would have guessed that a lad who never had any schooling in the accepted sense of the word would one day be the first chancellor of Brown University, would serve as the chief justice of the Superior Court, would be elected governor of the colony of Rhode Island for ten terms, and would be one of the famous few who signed the Declaration of Independence?

Hopkins's great-grandfather, Thomas Hopkins, had been one of the early settlers in Providence and had received a home lot in one of the distributions of land.[1] Like the others, he built his home near the Great Salt Cove, and in all probability dug clams on the shore in front of his house, hunted in the woods that topped the hill behind him, and explored the marshes and meadows on the west side of the cove. It is not at all unlikely that at some time or other he warmed his hands at Roger Williams's fireside as he talked with the great leader.

His son, Major William Hopkins, was born in 1650. He was a young man when King Philip's War broke out. Almost all of the inhabitants of Providence fled to the safety of Newport, but young Mr. Hopkins was ever after admired and respected because he was one of those who "stayed and went not away" to defend the town as best they could.[2] Several years later he married Abigail Whipple, daughter of Captain John Whipple, and moved to Pawtuxet.[3] There he lived for the rest of his life, and there his son William Hopkins, Jr. was born, and also his grandson, Stephen.

On his mother's side, Stephen's great-grandfather, Lawrence Wilkinson, settled in Providence in 1657, but

within a few years moved to the outlying country some ten miles northwest of the settlement.[4] Apparently he fell in love with the countryside, for it is said that at his death he owned a thousand acres. For New England, and particularly for the colony of Rhode Island, a thousand acres represented a sizable farm. His oldest son, Samuel, was a man greatly respected in the community. A staunch Friend, having embraced the Quaker faith when the Quakers were suffering bitter persecution in Massachusetts, he was an eloquent debater on history and government and was learned in law. He married Plain Wickenden, the daughter of a Providence minister. Samuel and his bride had six children, one of whom, Ruth, became the mother of Stephen Hopkins.[5]

Stephen was scarcely more than a baby when his parents and their two small sons (Stephen was their second child) moved west of the "Seven Mile Line" to the newly opened land of what is today the town of Scituate.[6] It took considerable courage to live in the thickly wooded section beyond the "Seven Mile Line" where only a muddy foot path connected one farmhouse with another, and the nearest doctor was some twenty miles to the east. Did young Mrs. Hopkins think about these considerations as she turned her face towards the west? Probably not, for although both the Hopkins and the Wilkinson families had originally settled in Providence, sooner or later they had moved out into the country and their primary concern became the development of their newly-acquired land. Then, too, her brother, Joseph, had already taken up land not far from where she was going to live.[7] His belief in the possibilities of the new land might have done much to influence young Mr. and Mrs. Hopkins to make their permanent home near him.

Like all country lads, the Hopkins boys—and it was not long before there were six of them—learned the straight-jacket routine of farming. The boys performed planting, weeding, milking duties and undoubtedly

William, Stephen, Rufus, John, Esek, and Samuel were impressed into service while their sisters, Hope, Abigail, and Susanna, helped their mother with endless tasks of a farmer's wife.

During the uneventful years of Stephen's childhood there was no school for him to go to. How and when he learned the three R's is not known.[8] Since, however, his mother was by birthright a Quaker, and since tradition has it that her father and grandfather were interested in reading and study and owned enough books to be considered a library, it seems sure that the Hopkins children learned to read and write in the commonest of all schools—at home. In addition, they were probably taught the great principles of righteous living—honesty, self-reliance, and industry, and to follow the dictates of one's conscience, or, as the Quakers express it, to follow the "guidance of the inner light." But all outdoors was a school for Stephen and his brothers. Inevitably he would acquire the indispensible knowledge of the weather and the seasons. From his uncle Joseph he learned the skill of surveying, and perhaps something of the philosophy of the country dweller, which would stand him in good stead later when he represented Scituate in the Rhode Island assembly. Young Stephen carrying the pole and chain, tramped hill and dale behind his uncle, absorbing some valuable technical knowledge in surveying. At the same time he learned the importance of land ownership and that a man always wanted to know the extent of his fields, the exact boundaries, and how his lands marched with those of his neighbors.

Two events were red letter days in Hopkins's life; one was his marriage in 1726 to Sarah Scott. A neighbor of his grandfather who lived in Louisquisset, young Hopkins had known her for a long time. It was a happy marriage, one blessed by seven children. Also at this time he was given a farm by his father, and for several

years Hopkins led the busy life of a farmer.

The second important event occurred in 1730 when Scituate, which formerly had been a part of Providence, was set up as a separate town.[10] This administrative change in Scituate opened the door of opportunity for Hopkins, now a young man of twenty-three. He was chosen as the moderator of the town council,[11] and also town clerk. This position, although perhaps not one of great prestige today, was important in the "new born" town. Naturally, it was vitally necessary to have the town records, land deeds, and titles accurately written up and filed. And it was not long before he was elected as one of the representatives for Scituate in the Rhode Island assembly which opened still further the door to his public life. For then it was that he began to get acquainted with his fellow citizens from all the towns in the colony. In 1735, he was chosen president of the Scituate Town Council. He held this position for six years and also served for five years as justice of the Inferior Court of Common Pleas for Providence County. Clearly, Mr. Hopkins was considered a man of ability and great promise.

In 1742 he decided to move to Providence for good. It must have been hard for him to take this step because he had known no other home than Scituate, and the life of a farmer. There his married life had begun, and there his children had been born. Then, too, for ten years he had played an important role in the life of the town; he knew everybody and everybody knew him. On the other hand, by 1742 many of the ties that had bound him to rural Rhode Island were gone; his grandfather, both of his parents, his uncle Joseph Wilkinson had died, and many of his brothers and sisters had moved away. It seems likely, however, the decisive factor in the matter was his election in 1739 as speaker of the Rhode Island assembly. Obviously, it would be much easier to perform the duties of this position if he lived in town,

rather than twelve or fifteen miles out in the country.

After Hopkins and his wife came to the conclusion that his future lay in Providence, he sold his farm in Scituate and moved into a little house that he had built on Towne Street (South Main Street), just a block south of Market Square.[12] It was a modest little house, but he lived there comfortably for the rest of his life. There he talked with his friends and colleagues, penned many letters and in later life wrote pamphlets and articles for *The Providence Gazette*.

When Hopkins settled in Providence, it was a small, compact community with a population of about four thousand. Practically everybody lived side by side on Towne Street with only a sprinkling of homes south of Market Square and on the west side of the Great Salt Cove. In the long period of peace after the end of Queen Anne's War in 1713, Providence had begun to build up a very profitable trade with the West Indies which were flung out like a pack of cards south of the tip of Florida. The chief products of the West Indian islands were sugar and molasses, and ships from the New England colonies bartered their commodities —lumber, dried fish, negro slaves, and a few manufactured articles—for the much desired sugar and molasses. Rhode Island had one special item which was in great demand—horses. These animals, called Narragansett pacers, were bred in the Narragansett Country, and, being small and tractable, were much liked by the sugar planters. Rhode Island shipmasters used to sail from island to island; Martinique, Trinidad, Barbados, or any others where they could make the best bargain. In exchange for their mixed cargo of goods and horses, they bought sugar and molasses, which was distilled into rum and sold throughout New England. This trade was the backbone of Rhode Island's prosperity, and built the fortunes of the Malbones, the Wantons, the Champlins, and Abraham Redwood in

Newport; and the Tillinghasts, the Nightingales, the Crawfords, and the Browns in Providence.

Not long after Hopkins settled in Providence he made his start as a merchant in the West India trade. According to the custom of the times, Hopkins frequently became a partner with other merchants by buying shares in the vessels bound for the West Indies. Eventually, he owned several ships himself, and now and again shared ownership with his brother, Esek, and with his son, Rufus.[13] By degrees he became closely associated with the four Brown brothers—Nicholas, Joseph, John, and Moses—in their many and varied ventures, and his friendship with them grew ever closer and more satisfying.

Meanwhile, he had entered on the long road to political success which led to forty years of public service, and for which his inheritance had fitted him. On both sides of Hopkins's family his forefathers had taken part in the administration of the colony.[14] His grandfather, Major William Hopkins, had served in the Rhode Island assembly for many years, and his uncle Joseph Wilkinson had held many offices in Scituate.[15] Stephen Hopkins was to prove a shining example of this family tradition.

Increasing prosperity brought with it the expansion of Providence, and the members of the Rhode Island Assembly spent much time administering local needs, such as the building of adequate roads, highways, and bridges. With his country background, Hopkins was keenly "road conscious"—the difficulties of bad roads, and the comfort of good ones. He was the proper man to call on and served on many committees for planning new highways south and west of Providence, as well as the widening and repairing of streets and roads already in use.

One of the improvements he was interested in was the cutting through of a new street east of Towne Street, half way up the hill. He saw the necessity for this very soon

after he moved to town and was one of the few forward-looking men who in 1743 petitioned the assembly in favor of this new street.[16] In spite of its speedy defeat, the petition was presented again in 1746. Although the second petition met with no more success in the assembly than before, the issue of a new street was not forgotten. For ten years it was argued back and forth until it was finally voted to undertake the project. Benefit Street was started in 1756 and completed from Power Street to Whipple's Gate two years later. Probably nobody enjoyed the great upheaval more than the small boys who watched the felling of the trees, and now and again, perhaps, were allowed to ride on oxcarts as the roots and rubble were carted away. At first the street was called "Back Street," but as it turned to be a benefit to everybody, it was rechristened "Benefit Street," and Benefit Street it has been ever since.

The boundaries of the colony of Rhode Island had long been a perennial problem, both in regard to Connecticut and Massachusetts. Fortune had ordained that Roger Williams's settlement included a splendid harbor, and the neighboring colonies, Plymouth, Massachusetts and Connecticut, appreciated its safety and fitness for trade. The inexact wording of the colonial charters concerning boundaries gave rise to controversies centered around the struggle for the control of Narragansett Bay.

The mutual boundary between Massachusetts and Rhode Island on the east was claimed by both colonies by virtue of their charters. When Plymouth was merged with the Bay Colony, Massachusetts had claimed Plymouth's share of the land on the eastern side of Narragansett Bay. Since the Bay Colony was never willing to let any opportunity slip by for the acquisition of land, she therefore pressed her claim vigorously. On the other hand, Rhode Island's charter of 1663 clearly stated that her eastern boundary ran from a point three

miles northeast of the head of the bay straight south to the sea.[17] Thus she naturally asserted her right to a strip of land three miles wide on the east coast of the bay. The real value of this shoestring bit of land lay not just in acreage, but in the fact that Narragansett Bay was the "front door" of the colony, the open road to the rest of the world. Rhode Island believed that it was vitally necessary to have the bay entirely within her boundaries.

During his first years as a member of the assembly, Hopkins was appointed to more than one committee to try to solve the problem of the colony's eastern boundary. More than once he and the other members of the various committees met with the Massachusetts commissioners seeking some agreement upon the boundary. Each colony appealed to the mother country for help, and at length a royal commission was appointed to try to cut the Gordian knot. The commissioners made a careful study of the matter, but Massachusetts refused to accept their decision, and once more appealed to England. Rhode Island also appealed, and this time she won her case; Massachusetts was forced to accept the line as designated in the Rhode Island charter.[18]

While Hopkins was busily engaged with his committee work, he was at the same time holding three other positions; clerk of the Providence Town Council, justice of the peace for Providence, and justice of the Superior Court of Judicature of Rhode Island. If one wonders how a man with no formal schooling and no legal training could carry out successfully these highly specialized legal duties, it should not be forgotten that in the eighteenth century law schools as they are known today did not exist in America. If a man owned one or two legal treatises such as Sir Edward Coke's *Institutes* or the treatise *Coke on Littleton,* which were the Bibles for lawyers, one could learn enough of court rulings and procedure to handle all but the most intricate legal

problems. Undoubtedly, Hopkins did own these standard books to which he could turn for help.

The decade of the fifties brought him both good and bad fortune. At times, he must have thought that the hand of the Lord rested very heavily on him for he lost two sons and his wife within a few months of each other.[19] His son, Sylvanus, was murdered by the Indians in Nova Scotia in 1753, and about six months later another son, John, was lost at sea. Hardly had he recovered from these two blows when his wife died. His grief was in part assuaged by his marriage in 1757 to Mrs. Anne Smith.[20] She had four children, the eldest of whom was already married. The other three with their mother came to live with Hopkins, and once more his life was filled with affection and companionship.

Meanwhile, he had become interested in an unusual project. As there was no public library in Providence, Hopkins and four of his friends decided to order from England hundreds of books of general interest that would form a "library" which they would own together, and could borrow and enjoy. When the books arrived, they found that there was really no place large enough to store them, so in 1754 they sent a petition to the assembly asking for the privilege of placing them in the Council Chamber of the County House. It stated that the purchasers of these books thought that they would be "a real ornament to the House, and could afford agreeable amusement to the members of the assembly in their leisure hours."[21] Moreover, they promised to pay for the bookshelves. This request was granted, and the library was successful, but alas, five years later the County House burned down and most of the precious collection of books was lost. That the books which constituted the first "Public Library" in Providence had been appreciated by the members of the assembly is shown when they were raising money to rebuild the County House; they included £1,000 towards the pur-

chase of books "to be forever kept in the town of Providence; free access unto which shall always be had by the members of the Assembly."[22]

Although the recent years had appeared to be filled with sorrow for Hopkins, Lady Luck had also offered him a cornucopia of bounty. Perhaps the most interesting experience during this period was the Albany Congress, which he attended in 1754. This conference was called together at the suggestion of English officials because, although England and her colonies had recently defeated France, they feared that war might break out again at any time. Should this happen, England would again expect assistance from the American colonies, and she felt that an accepted plan of union and cooperation would be of immense value to her. Discussions and proposals for colonial union, therefore, were important items on the agenda.

Hopkins was undoubtedly proud to represent Rhode Island and looked forward to meeting the other delegates. For him the most rewarding event was meeting and working with Benjamin Franklin, because, like everyone else, Hopkins was an admirer of the great philosopher and scientist. The two men took to each other at once, and their friendship lasted for the rest of Hopkins's life.[23] He was appointed on the committee to prepare a program for union, and in this way he learned the details of Franklin's plan of union which he had brought to the Congress. Hopkins was converted to the need for intercolonial cooperation, but on his return home he was unable to convince the Rhode Island Assembly of this. In fact, none of the colonies accepted the idea of cooperation and colonial union at this time, and it was many years before they were willing to work together for another cause of vital importance—independence.

He had hardly gotten back from Albany when in 1755 he became a candidate for governor of Rhode Island

and was elected. His election was a great triumph because almost since the establishment of the colony the wishes of Newport—the center of wealth and prestige—had usually been the controlling factor in the choice of the governor. Consequently nine times out of ten, Rhode Island governors had been Newport residents. While Hopkins was well known in Newport by 1755 and had held more than one position in the Rhode Island assembly, he was not in the inner circle of that seaport town, nor was he a member of the closely knit social group of Kings County. In sharp contrast, he was a relative newcomer to the political scene from the hinterland of Rhode Island. His election, therefore, may be said to have been due to general recognition of his ability, as well as to the backing of the Brown brothers.

Although the Seven Years War did not officially break out until 1756, it was obvious that the French were preparing for war. England, also, was on the alert, and in 1755 called on her American colonies to start preparations. When, therefore, Hopkins took office as governor in the spring of 1755, to all intents and purposes he found himself with a war on his hands. During his first term of office, his energies and those of the assembly were taken up with the problems of war, while the usual day-to-day matters were brushed aside. When war did break out in 1756, scarcely a week went by when the raising of companies of soldiers, their training, their equipment—blankets, tents, ammunition, and the like, as well as their transportation to points along the boundary of Canada did not occupy his thoughts and attention.

Hopkins's devotion to duty was recognized by others outside the colony. His heart must have been warmed to receive, in 1759, a letter from Colonel Henry Babcock who was in command of a Rhode Island regiment in Canada. He said, " . . . you must excuse me, Sir, when I acquaint you that the general as well as several other

officers of distinction mention you with the greatest respect as being hearty for the defense of the country, and a firm friend . . . to His Majesty's interest in America."[24]

Meanwhile, when he was campaigning in 1756 for a second term as governor, he became engaged in a bitter political feud with his opponent, Samuel Ward, who was the son of a former Rhode Island governor. Political campaigns often produce invective, and the campaign of 1756 ran true to form in this respect. Probably the animosity would have been forgotten once the election was over, had not Hopkins made the mistake of suing Ward for libel and asking £2,000 for damages.[25] The trial was postponed several times, and Hopkins finally withdrew his suit, but the controversy was not forgotten, and the colony became sharply divided into two camps, pro-Hopkins and pro-Ward. This unhappy situation continued for several years as the two contenders for Rhode Island's highest political office faced each other again and again. Pamphlets extolling the virtues of the two antagonists were widely circulated, and a good deal of money, as well as gifts of corn, sugar, cheese, and the like, passed from hand to hand in the attempt to influence the voters in favor of one candidate or the other.[26]

The Hopkins "machine," of which the Browns of Providence were ardent members, helped to get Hopkins elected seven times, while Samuel Ward became the governor only three times—in 1762, 1765, and 1767. By 1769, both Hopkins and Ward agreed to bury the hatchet, and thereafter political peace reigned in Rhode Island.

While the war was being fought, it would seem as though there were hardly a day that Hopkins could call his own. Although burdened by political disputes and his administrative duties in the assembly, Hopkins continued to further Rhode Island's effort in the French War. He also attended a second congress in Albany in 1755, and a year later went to Boston to a convention

for consultation with the English commander in chief, the Earl of Loudoun, on the conduct of the war. Hopkins also served as a member of the Rhode Island Committee of War, and for five years (1751-56) had been serving as the chief justice of the Superior Court.

Although he was by now fifty years old, such was his ardor for victory over the French that on learning of the surrender in 1757 of Fort William Henry on Lake George to the enemy, he volunteered for a campaign against Canada.[27] A group of some 200 men was quickly formed, and Hopkins was chosen as their commander. They were about to start out when news was received that the enemy had retreated and their services, so gladly offered, were no longer needed.

At last, in 1763, the Seven Years War was over, and a new era was ushered in for the American colonies. France, now defeated in war, ceded Canada to England, and for a short time it looked as though peace and prosperity had come to stay. To be sure the feeling of optimism did not last long, for England soon discovered that Canada was a pretty expensive luxury, because she had not only to provide for the government of her new empire, but maintain an army of occupation to keep the peace along the border between the Indians and the colonies. The inevitable result was that she was faced with the problem of finances, which she sought to solve by remodeling her policy of taxation. Thus, the colonial dreams of utopia evaporated and the struggle began between the mother country and her increasingly hostile American colonies.

During the critical years, although Hopkins occupied the governor's chair but rarely, he still played an active part in the colony. He served for five years in the general assembly as deputy from Providence, and once more took on the duties of chief justice of the Superior Court. He also embarked on several other activities which added color and variety to his life.

The Providence Gazette had been founded in 1762, and from time to time Hopkins wrote articles which were published in the paper. Some, perhaps, were published anonymously, while others, according to the custom of the times, appeared under fictitious names, or merely with an initial. In 1764, he was the author of an *Essay on Trade,* which was a protest against the reenactment by England of the former Molasses Act that had imposed a duty on sugar and molasses not purchased in the British West Indies.[28] This Act had been on the books some thirty years and had always been hated. It had never produced much revenue for England, however, as the New England merchants had continued to trade with the French and Dutch sugar planters, and had become adept at smuggling in these products. Now, to have another Molasses Act which would replace the former one and which, it was understood, was to have definite provisions for vigorous enforcement, was a bitter pill to swallow. Shortly after the *Essay on Trade* had appeared in the *Gazette,* he condensed it, and then, with a new title—*A Remonstrance of the Colony of Rhode Island to the Lords Commissioners of Trade and Plantations*—the assembly voted to send two copies to Rhode Island's agent in England to be presented to the members of the Board of Trade.[29]

Before the year was over, he took up his pen once more and wrote a pamphlet which he called *The Rights of Colonies Examined.*[30] This was a very thoughtful exposition of the basic relationship between colonies and a mother country. His wide knowledge of history enabled him to begin with a discussion of the privileges and liberties of the Greek and Roman colonies, which privileges and liberties England had extended to her colonies, and which had been included in the charters she had granted to the New England colonies. He pointed out that "British colonists went out on a firm reliance of a solemn compact and royal promise and

grant that they and their successors forever . . . should be partakers and sharers of all the privileges and advantages of the then, English, now British, Constitution" With this as a background, he went on to criticize not only the tax on foreign sugar and molasses, but the proposed stamp tax. He concluded by saying that "the first planters of these colonies, the American colonies, have kept due order, and supported a regular government, have maintained peace, and practiced Christianity . . . have demeaned themselves as loyal, as dutiful, and as faithful subjects ought" Why, Hopkins concluded, "should the gentle current of tranquility, that has so long run with peace through all the British States and flowed with joy and happiness in all her countries, be at last obstructed, be turned out of its due course into unusual and winding channels, by which many of those states must be ruined?"[31] This well reasoned pamphlet was published in *The Providence Gazette* and copies of it were sent to England to be printed there.

Hopkins was full of foreboding as he looked into the future, but unexpectedly he discovered a new and quite different interest. He had always been an ardent reader and had always been interested in education. He was therefore more than pleased to learn of the possibility of a college—Rhode Island College (later Brown University)—being established in Warren. With his many friends he cooperated to make this a reality, and it must have been a source of great pride to him when in 1765 he was chosen chancellor of the university, and also one of the trustees.[32] Thereafter, Brown University and its young president, James Manning, held a very special place in his heart. And still another honor was to come his way. In 1768 Hopkins was elected a member of the American Philosophical Society.[33]

A year later he had the once-in-a-lifetime pleasure of working with Joseph Brown in the observation of the

transit of Venus. Brown had imported from England a special telescope, and the two friends and a small group of others watched the great spectacle from Benefit Street at a point not far south of College Hill. An astronomer, Benjamin West, wrote an account of this and dedicated it to Hopkins, saying in the introduction that "much might be said with respect to your Honor's superior abilities in mathematics and natural philosophy; but without flattery these are the least of your achievements, when compared with your profound skill in civil police (policy), and the wise government of a people."[34]

As Hopkins watched the planet glide across the sun, perhaps he had a fleeting hope that this was an omen of good fortune for the future. But such hopes were not to be realized. By this time, the differences between England and the colonies had not been ironed out in spite of a brief period of calm after the repeal, in March 1766, of the Stamp Act. The burning of the British revenue schooner H. M. S. *Gaspee* in Narragansett Bay, on the night of June 9, 1772, advertised to everybody on both sides of the Atlantic the deep dissatisfaction of the Rhode Islanders with the policies imposed by the mother country.[35]

It could not be supposed that England would pass over this outrage quietly, and a royal commission was appointed to investigate the case and was instructed to send those convicted of the attack to England for trial. This placed Hopkins in a very serious dilemma. As chief justice of the Superior Court of Common Pleas, it was his duty to cooperate with the commissioners as they carried on their examination of witnesses. On the other hand, as a Rhode Islander, he knew who had taken part in the burning of the ship, and he was desperately afraid that his fellow colonists would be convicted. Even worse, the instructions to send the perpetrators of the vandalism to England for trial were very frightening.

Like everyone else, he feared that the chances for a fair trial in England were negligible. What, then, would be the fate of these men three thousand miles away from home, who had been declared guilty of burning one of His Majesty's ships at a time when England was officially at peace with her colonies?

Hopkins took a determined stand by announcing publicly that he would not countenance the deportation of any Rhode Islander to England for trial.[36] In the end, however, this decision was not put to the test, for, although everybody knew who had rowed down the bay on that fateful night in June, the royal commissioners were unable to get any incriminating evidence against anybody. Only one witness was found who gave straightforward testimony, but finally this was dismissed as unreliable. At length, after a year of frustrating delays, the commissioners realized that they were beaten, and the case was dismissed.[37]

Two years after the burning of the *Gaspee,* a giant step was taken towards colonial union and independence by the calling together of the First Continental Congress in September 1774 in Philadelphia. Just which colony first suggested this important conference is not definitely known, and many colonies have claimed that distinction, but perhaps the palm should be awarded to Rhode Island. Furthermore, it is not too wide of the mark to believe that the venerable Stephen Hopkins who had for years preached the importance of colonial union, and who had attended many colonial conferences, was the man who started the ball rolling. However that may be, it is certain that a town meeting in Providence on May 17, 1774 passed a resolution proposing a general conference to discuss the many problems facing the colonies, and "for establishing the firmest union, and adopting such measures as to them (the members of the Congress) shall appear the most effectual to answer that important purpose."[38] A few weeks later the Rhode Is-

land assembly passed a Resolution in favor of a "Convention of representatives from all the colonies . . . to establish the rights and liberties of the colonies upon a just and solid foundation."[39] At the same meeting Stephen Hopkins and Samuel Ward were chosen as delegates to the Congress.

After the Congress was called together and organized—Peyton Randolph of Virginia was chosen as president—Hopkins was appointed on two committees. The duty of the first was to draw up a paper on the rights of the American colonies, and the second committee began work on a survey of the trade and manufactures of the colonies; this would give a picture of the resources of the colonies.

While listening to the debates in the meetings of the Congress and taking part in the informal discussions which took place in the taverns of Philadelphia, he must have been heartsick to discover that the general sentiment of the members was overwhelmingly opposed to taking any radical steps against the mother country. On the contrary, the delegates were determined to keep the door of reconciliation wide open, and even after weeks of debate were in favor of only appeals to the mother country for understanding and cooperation. To carry out their decision, an "Address to the King," and a similar "Address to the People of England" expressing the attitude and thinking of the colonies, and finally a Declaration of Rights claiming the rights of the American colonists to life, liberty, and property were prepared to be sent to England.

The only positive action taken was the organization of the Continental Association which banned importation of all British goods into the colonies, and the exportation of all colonial products to England.[40] It was thought that this would prove to be a very strong "weapon," since it would affect the pocketbooks of the English merchants and therefore would probably create a

strong sentiment in favor of the relaxation of the oppressive policies in operation against the American colonies. These measures completed the work of the First Continental Congress. After agreeing to hold another Congress, if necessary, in the spring of 1775, the delegates went home hoping against hope that the relations between England and her colonies would somehow take a turn for the better.

These hopes turned out to be forlorn indeed, and the Second Continental Congress met again in Philadelphia in the spring of 1775. The situation had by now definitely deteriorated. The nonimportation of British goods had not proved effective in softening public opinion in England; the Address to the King had been ignored; and Parliament was still adamant in demanding obedience from the recalcitrant colonies to the existing laws. The port of Boston had been closed as a punitive measure after the Boston Tea Party, and for some months the town had been suffering the rigors of unemployment and food shortage, while the battles of Lexington and Concord had already taken place about a month before the Congress had been called together.

While the Congress still continued to explore all possible means of preventing a break with England, Hopkins was ready to start preparations for the worst—war. He openly said, "The gun and bayonet alone will finish the contest in which we are engaged, and any of you who cannot bring your minds to this mode of adjusting the question better retire in time as it will not perhaps be in your power, after the first blood is shed."[41] He admired both John Adams and Samuel Adams, and he therefore voted in favor of their candidate, George Washington, as commander in chief of the Continental Army. He also served on several committees—one for organizing the militia, a second one for procuring cannon, and a third to establish a Continental Navy. Needless to say, he was proud and pleased when he secured

the appointment of his brother, Esek, as commander of the infant navy.

Meanwhile, Rhode Island had been traveling rapidly towards the point of no return, and preparations for war had been going on for many months—the enlistment of troops for active duty, gathering of supplies of every kind, planning for the defense of Narrangansett Bay, and pondering the ever present problem of finances.

On May 4, 1776, eight weeks before the members of the Continental Congress voted in favor of the Declaration of Independence, the Rhode Island assembly, meeting in Newport, took the momentous step of severing allegiance to the British Crown by the passage of an act declaring that

> whereas George the Third, King of Great Britain . . . is endeavoring to destroy the good people of this Colony, and of all the United Colonies . . . it becomes our highest duty to use every means with which God and Nature have furnished us in support of invaluable rights and privileges to oppose that power which is exerted only for our destruction.
>
> Be it therefore enacted by this General Assembly and by the authority thereof it is enacted, that an Act entitled 'an Act for the more effectually securing to His Majesty the allegiance of his subjects in this his Colony, and dominion of Rhode Island and Providence Plantations', be and the same is hereby repealed[42]

Thus quietly and without the fanfare of trumpets did the little colony of Rhode Island declare its independence. Never again would the records of the assembly be concluded with the phrase "God save the King"; instead, for a short time "God save the United Colonies" was used, and later, "God save the United States."

In spite of the fact that many members of Congress were haunted by the fear that the future of the colonies, without the protection of the mother country, could

only mean disaster and ruin, the time had come when it was impossible to postpone the great decision any longer. A motion was presented by Richard Henry Lee of Virginia on June 7, 1776, which placed the situation clearly before the Congress. It stated "that these United Colonies are and of a right ought to be free and independent states; that they are absolved from all allegiance to the British Crown, and that all political connection between them and the State of Great Britain is and ought to be totally dissolved."[43]

Face to face at last with the decision of severing relations with the mother country, it was decided to put off action on Lee's motion for three weeks in order to enable the delegates to find out the general sentiment of the colonies on this all-important question. It was realized, however, that some preparation for the future must be made, and without further delay a committee of five was chosen to draw up a Declaration of America's position which could be voted on should Lee's motion be adopted. Another committee was also set up to devise a plan which would give the Congress the authority to work with and for the states not only on the conduct of war, but as a sort of central government after independence was secured. Hopkins was well known to be a staunch advocate of colonial union, and it was natural that he should be appointed on this committee.[44] When its work was completed, the plan was called the Articles of Confederation.

At last, the great day arrived when, after long and thoughtful debate and some changes in the wording, the Declaration of Independence was accepted and signed. Hopkins was now a feeble old man and was afflicted with what was known in those days as the "shaking palsy." His signature was shaky indeed, but his spirit was strong. He was convinced that independence offered the only solution to the problems confronting the colonies, and he believed that this would some day

be won.

Soon afterwards he returned home to rest and recuperate. He was appointed a delegate for four more years, but he was forced to decline on account of his health. He could, however, help the cause at home, and for three years he worked incessantly for his beloved Rhode Island. And, indeed, "these were the times that try men's souls" for the enemy had invaded the state and occupied Newport. Proud Newport, the garden city of New England, was reduced to suffering many indignities and tribulations for three years while the British troops remained in occupation of the town.

Hopkins served on the Committee of War for two years. Its purpose was to cooperate with the other New England states for the general defense of New England. He was also a member of the Rhode Island Council of War. This proved to be an arduous assignment, because the conduct of the war rested almost entirely in its hands, and in carrying out the wishes of the assembly it met six days a week every other week. He was, to be sure, deeply absorbed in the war effort at home, but at the same time he could not forget the Continental Congress, and he kept in touch with its work through correspondence with some of his friends there.

He had been greatly interested in the Articles of Confederation which he had helped to write. Although this document had been introduced into the Congress only a few days after the Declaration of Independence had been signed, its many details had not been ironed out and endorsed until three months later. Even then, action on it was greatly delayed. It was sent to the states for ratification, and five years went by before enough states ratified it to make it official. For Hopkins, when it was at last legally in operation it was a dream come true—colonial union. It is interesting to note that Rhode Island was the first state to ratify the Articles of Confederation. A glowing testimony to Stephen Hopkins and

his belief in the importance of colonial union, it could hardly have been otherwise.

In 1781 he had the great pleasure of an unexpected visit from General Washington, who had come to Rhode Island to consult with the French troops who were quartered in Newport.[45] There, in the front parlor of his little home, Hopkins entertained the commander in chief of the Continental Army, and heard first hand the plans for the coming campaign. His friend, Moses Brown, who happened to be there when Washington arrived, remarked on the unaffected friendliness of the two men as they talked together about the issues of war.

Washington's visit might be said to mark the end of the chapter of Hopkins's active life; he was by now seventy-five years old and in poor health. Moreover, it was not long after this that he suffered the loss of his wife, who died in 1782.[46] This was hard to accept, but he was blessed by having many friends to turn to for companionship. He was very popular as he had a wealth of memories to share with his acquaintances who enjoyed hearing him tell of his varied experiences. Without question, his closest friends were the Brown brothers who he was bound to by the ties of family, religion, literary and civic sympathies, and innumerable commercial enterprises. With Nicholas he could discuss business in general, and make plans for the future when the war was over; with Joseph there was always their untiring mutual interest in science; with John who was very active in the general assembly he could keep in contact with the war effort; and with Moses he had the special bond of the Quaker faith, to which they both subscribed, as well as their love of reading and study.[47]

He lived to hear the bell of the First Baptist Church ring all day long in 1783, announcing the glorious news that England had at last signed the Treaty of Peace, which meant that the war was over, and probably he attended the service of thanksgiving held in the Baptist

Church to thank the Lord for His gift of peace with honor, and independence. By now his days were numbered, but one more honor awaited him—the award of an honorary degree of LL.D. from his beloved Brown University in 1784.[48]

Stephen Hopkins died at home on July 13, 1785. His body was escorted to the North Burial Ground by a large group of his fellow citizens from all walks of life, which demonstrated not only his manifold interests and activities, but his universal admiration as well. His monument, suitably inscribed, mentions his many public services, and his rare abilities as an individual.

Let us today, almost two hundred years later, contemplate reverently the inscription:

Sacred to the memory of
the illustrious
Stephen Hopkins
of revolutionary fame
attested by his signature
to the Declaration
of our national independence
Great in counsel,
from sagacity of mind;
Magnanimous in sentiment,
firm in purpose,
and good as great
from benevolence of heart;
he stood in the first rank of
Statesmen and patriots,
Self-educated,
Yet among the most learned of men:

his vast treasury of useful knowledge
his great retentive
and reflective powers
combined with his social nature
made him the most interesting
of companions in private life,
His name is engraved
on the immortal records
of the revolution
and can never die.

His titles to that distinction
are engraved
on this monument
reared by
the grateful admiration
of his native state
in honor
of her favorite son.[49]

Appendix

Public Services of Stephen Hopkins

1730-1731	Moderator, Scituate Town Meeting
1731-1741	Town Clerk, Scituate
1732-1738	Deputy from Scituate, Rhode Island General Assembly
1735-1741	President, Scituate Town Council
1736	Justice of the Peace, Scituate
1736-1740	Justice of the Inferior Court of Common Pleas, Providence County
1740-1741	Member of the Eastern Boundary Commission
1741-1742	Deputy from Scituate, Rhode Island General Assembly
1741-1743	Speaker, Rhode Island General Assembly
1741-1744	Clerk, Providence County Court of Common Pleas
1742-1745	Deputy from Providence, Rhode Island General Assembly
1744	Justice of the Peace, Providence
1746	Rhode Island Delegate to a Congress of the Colonies
1746-1749	Deputy from Providence, Rhode Island General Assembly
1747-1749	Justice of the Rhode Island Superior Court of Judicature
1748	Member of the Northern Boundary Commission
1749	Speaker, Rhode Island General Assembly
1751-1752	Deputy from Providence, Rhode Island General Assembly
1751-1756	Chief Justice of the Superior Court
1754	Delegate to the Albany Congress
1755-1761	Governor of Rhode Island

Stephen Hopkins

1755	Delegate to a Second Colonial Congress at Albany
1757	Member of a Committee of War of Rhode Island
1757	Delegate to a Colonial Congress at Boston
1763-1764	Governor of Rhode Island
1764	Chairman of the Rhode Island Committee of Correspondence
1764-1785	Chancellor of Rhode Island College
1764-1785	Member of the Board of Trustees of Rhode Island College
1767-1768	Governor of Rhode Island
1770-1775	Deputy from Providence, Rhode Island General Assembly
1770-1776	Chief Justice of the Superior Court
1773-1774	Chairman, Rhode Island Committee of Correspondence
1774	Member of the Providence Committee of Safety
1774	Delegate to the First Continental Congress
1775-1776	Delegate to the Second Continental Congress
1776-1778	Member of the Rhode Island Council of War
1776	Delegate to the Convention of New England States, Providence—chosen president
1777	Deputy from Providence, Rhode Island General Assembly
1777	Delegate to the Convention of New England States, Springfield—chosen president
1779	Delegate to the Convention of New England States, Hartford

Notes

1. John H. Cady, *The Civic and Architectural Development of Providence*, p. 10.
2. William E. Foster, *Stephen Hopkins, a Rhode Island Statesman*, Part I, p. 17.
3. *Ibid.*, p. 21.
4. Israel Wilkinson, *Memoirs of the Wilkinson Family in America*, p. 38.
5. Charles C. Beaman, *An Historical Address*, p. 16.
6. Foster, *Stephen Hopkins*, I, 31.
7. Beaman, *An Historical Address*, p. 14.
8. *Ibid.*, p. 17.
9. Foster, *Stephen Hopkins*, I, 60.
10. Arnold, *History of Rhode Island*, II, 102.
11. Foster, *Stephen Hopkins*, I, 64. A list of the public services of Stephen Hopkins may be found in Appendix Z, pp. 253-56. See also *Rhode Island Colonial Records*, Vols. III-IX.
12. Foster, *Stephen Hopkins*, I, 90. There is considerable uncertainty among historians as to whether Hopkins built his home in Providence or purchased it. Foster quotes a letter from Moses Brown to Robert Waln in 1823 saying that Hopkins built the house. Unfortunately this letter of Moses Brown, formerly listed in the Rhode Island Historical Society Library, is missing. The Hopkins House is situated today on the corner of Benefit Street and Hopkins Streets.
13. Letter of Moses Brown to Tristram Burgess, 1836.
14. *Rhode Island Colonial Records*, III, 179, 184, 429.
15. Wilkinson, *Memoirs*, p. 77.
16. Henry C. Dorr, *The Planting and Growth of Providence*, pp. 147, 148.
17. The Royal Charter, 1663, Original Copy, Rhode Island State House.
18. Acts of the Privy Council, 1720-1745, #444.
19. Foster, *Stephen Hopkins*, II, Appendix C, pp. 210, 212, 213.
20. *Ibid.*, p. 97.
21. *Rhode Island Colonial Records*, V, 378, 379.
22. *Ibid.*, VI, 215.
23. Foster, *Stephen Hopkins*, I, 185.
24. *Rhode Island Colonial Records*, VI, 216.
25. Foster, *Stephen Hopkins*, II, Appendix K, pp. 231, 232.
26. James B. Hedges, *The Browns of Providence Plantations, Colonial Years*, p. 191.

Stephen Hopkins

27. John Sanderson, ed., *Biography of the Signers to the Declaration of Independence,* VI, 241.
28. *The Providence Gazette,* January 14 and 21, 1764.
29. *Rhode Island Colonial Records,* VI, 378-83.
30. *Ibid.,* pp. 416-27.
31. *Op. cit.*
32. Foster, *Stephen Hopkins,* II, 101.
33. Sanderson, *Biography of the Signers,* p. 251.
34. Benjamin West, *An Account of the Observation of Venus Upon the Sun.*
35. Arnold, *History of Rhode Island,* II, 312.
36. Foster, *Stephen Hopkins,* II. 95.
37. *Rhode Island Colonial Records,* VII, 57-192, gives a documentary account of the investigation of the burning of the *Gaspee.*
38. William R. Staples, *Annals of the Town of Providence,* p. 235.
39. *Rhode Island Colonial Records*, VI, 246.
40. John Fiske, *The American Revolution,* I, 112.
41. Edwin M. Stone, *Life and Recollections of John Howland,* p. 199. This statement of Stephen Hopkins was quoted by Paul Revere, a friend of John Howland. While Revere was in Philadelphia he stayed at the same lodging house as Hopkins.
42. *Rhode Island Colonial Records,* VII, 522.
43. Fiske, American Revolution, I, 194.
44. Foster, *Stephen Hopkins,* II, 136.
45. Sanderson, *Biography of the Signers,* VI, 253-54.
46. Foster, *Stephen Hopkins,* II, Appendix C, 214.
47. *Ibid.,* I, 95-96.
48. Wilkinson, *Memoirs,* p. 373.
49. Foster, *Stephen Hopkins,* II, Appendix Y, 252.

Bibliography

Primary Material

Bartlett, John R., ed. *The Records of the Colony of Rhode Island and Providence Plantations.* 10 vols. A. C. Greene, 1856-65. Vols. III-IX.

Letter of Moses Brown, 1836, Rhode Island Historical Society.

The Providence Gazette, 1764.

Benjamin West. *An Account of the Observation of Venus Upon the Sun,* 1769.

Secondary Material

Arnold, Samuel G. *History of the State of Rhode Island and Providence Plantations.* 2 vols. D. Appleton & Company, 1860.

Beaman, Charles C. *An Historical Address, July 4, 1876.* Capron & Marshall, 1877.

Cady, John H. *The Civic and Architectural Development of Providence, 1636-1950.* Ackerman Standard Press, 1957.

Dorr, Henry C. *The Planting and Growth of Providence.* Sidney S. Rider, 1882.

Fiske, John. *The American Revolution.* 2 vols. Houghton, Mifflin & Co., 1897.

Foster, William E. *Stephen Hopkins, a Rhode Island Statesman.* Sidney S. Rider, 1884.

Hedges, James B. *The Browns of Providence Plantations, Colonial Years.* Harvard University Press, 1952.

Sanderson, John, ed. *Biography of the Signers to the Declaration of Independence..* R. W. Pomery, 1823. Vol. VI.

Staples, William R. *Annals of the Town of Providence.* Knowles & Vose, 1843.

Stone, Edwin M. *Life and Recollections of John Howland.* George H. Whitney, 1857.

Wilkinson, Israel. *Memoirs of the Wilkinson Family in America.* Davis & Penniman, 1869.

A Portrait Album

John Howland

John Howland

One of Rhode Island's great and largely unsung leaders is John Howland. He was born in 1757 in Newport, the second son of good, but not wealthy parents, Joseph and Sarah Howland.

He had a happy childhood playing about the streets and down at the wharves of Newport, which at that time was one of the most prosperous towns in New England. It had been founded in 1639 by William Coddington, a companion of Anne Hutchinson, and because of its location at the southern end of the island of Rhode Island, it had become a very busy commercial port. Now, in the middle of the eighteenth century, its harbor was lined with wharves, warehouses, and shipyards—a veritable paradise for boys to explore. A block away on Thames Street were the houses and gardens of the rich merchants, Alexander Redwood, Christopher Champlin, Godfrey Malbone, and others, each of whom had made a fortune in the West India trade.

Like most boys of his background, John got his start in education at home where he was taught by his parents to read and write, and his textbooks were a speller, a Black Letter Bible, and the Psalter.[1] He did, however, attend a school for a short time. Perhaps his aptitude for learning prompted his parents to try to give their bright little son as good an education as possible. He proved a good student and great was his pride and satisfaction when one day he defeated a rival in a spelling test.[2]

It was during his boyhood that the American colonies were plunged into the quarrel with the mother country which eventually resulted in independence from Great Britain. The first step in the long, drawn-out struggle was the resistance to the Stamp Act. Newport reacted violently to the stamp tax. Howland was only a small boy at this time, but he remembered for the rest of his life

the vandalizing of the homes of Augustus Johnson, who had been appointed the stamp collector, and those of two other men who were to be his assistants, Martin Howard and Dr. Thomas Moffatt.[3] Their books, papers, and furniture were looted by the mob and ruined. He never forgot the sight of those houses when, with the rest of the boys of the town, he stared the next day at the results of the uprising.

The year 1770 marked a turning point in his life. He was now thirteen years old, and after some thought, his parents apprenticed him to Mr. Benjamin Gladding, a relative of the Howlands, who was a wigmaker and barber in Providence. His mother packed his bag, and no doubt admonished him to remember all the precepts of good behavior that she had taught him, kissed him good-bye, and the lad sailed up Narragansett Bay to Providence. He landed at a wharf not far from the present Superior Court House, and apparently from the moment he stepped on shore he fell in love with Providence. He lived in the city the rest of his life and became one of its devoted citizens.

He was fortunate to learn his trade in Mr. Gladding's shop, and it was there that he overheard discussions of the burning issues of the day, especially the arguments over the relations between the colonies and England, which worsened as the months and years went along. There, too, he met the prominent men of the city, many of whom became his friends in later years.

Then, in 1772, occurred the burning of the *Gaspee*. This story is well known to every Rhode Island school child. The *Gaspee*, commanded by Lieutenant Duddington, was stationed near Newport to search for possible smuggled merchandise. On June 9 the *Gaspee* began pursuit of a New York sloop, *Hannah*, captained by Benjamin Lindsey. Captain Lindsey knew very well the deeps and shoals of the bay and sailed his sloop through some shallow water close to the shore. As his

boat was lighter than the *Gaspee,* the result was just what he hoped for—the British ship stuck fast on a sandbar, while Captain Lindsey sailed triumphantly up to Providence, knowing that his pursuer was trapped on the sandbar until the turn of the tide.[4]

Arriving in town, Lindsey told his story gleefully, and almost immediately some young men of Providence conceived the idea of making use of this glorious opportunity to teach Lieutenant Duddington a lesson, for he was bitterly disliked in the colony on account of his high-handed practices. They decided to go down to the *Gaspee* and demand its surrender. The daring plan once conceived developed with amazing speed. A drumbeat through the streets of Providence drew a goodly crowd of volunteers, and before long eight long boats started off from the pier adjoining Market Square. Naturally, young John Howland, now fifteen years old, was eager to go on the great adventure, but to his disappointment his uncle hurried down to the square, and ordered him out of one of the boats. He had no desire to have his young apprentice involved in this daredevil exploit.

It was not long after the burning of the *Gaspee* that Rhode Island began to definitely prepare for war by organizing the militia into companies called "Minute Men." Howland joined one of these groups[5] and saw his first service in September 1775, when his company was sent to Newport to prevent, if possible, Captain James Wallace, who commanded the British fleet around Newport, from further harassing the colonists by molesting and driving off their cattle. The arrival of the soldiers had the desired effect, and Captain Wallace for a while ceased to be a nuisance to the settlers.

In January 1776, he enlisted in the Seventh Company of the Rhode Island Regiments, and was again posted to Newport. As one of the soldiers, he was present at the Court House when the Declaration of Independence was read by an adjutant of Colonel Richmond's regi-

ment.[6] A thirteen-gun salute, thirteen cheers, and hats flung high in the air greeted the reading. He later served in the battle of New York, and also at Trenton (although not called into action) and also at Washington's victory at Princeton.[7] Then he became ill, and at length was mustered out of the service. While his role in the war was not as arduous or exhausting as that of many soldiers, he served his country to the best of his ability, and his admiration for Washington was deep and heartfelt.

Home once more, the young man went back to Mr. Gladding's barber shop as an employee. When at last the war was over, he opened his own shop on North Main Street, near the corner of North Main and College Hill and became very successful.[8] He had such a pleasant personality that it wasn't long before his place of business became almost the "Civic Center" of Providence. He seemed to know everybody, and counted among his many customers, Dr. James Manning, President of Brown University and the pastor of the First Baptist Church. Customers often remained to visit with each other after the business of shaving and shampooing was completed. Consequently, if a man wanted to confer with somebody, more likely than not he would drop into Mr. Howland's shop, and have a good chance of finding the man he wanted to see. An added advantage lay in the fact that at Howland's shop one could hear the latest news of the day.

In 1788 he married Mary Carlile, a great-granddaughter of James Franklin, the oldest brother of Benjamin Franklin. He took his bride to the house he had built on Benefit Street where, now that peace had come to the new independent states, building was going on apace. They had thirteen children, but only five lived to maturity.

Like all Rhode Islanders, he read with great interest a copy of the Federal Constitution when it was printed in

The Providence Gazette, and no doubt his shop hummed with heated discussion over the possibilities of its acceptance, and of the completely new concept of a nation with an elected head. Like most Providence citizens, he must have chafed as the months drifted by and the Rhode Island assembly refused even to call a Constitutional Convention to consider the great document, and to vote yes or no on ratification. Probably Howland was in the crowd on a Sunday morning outside the State House in 1789 waiting to hear if at last, after two years of opposition, the members of the assembly voted in favor of calling a convention to consider ratification.

When the glorious news that the convention had ratified the Constitution on May 29, 1790, reached Providence at eleven o'clock that night, in spite of the lateness of the hour, church bells rang and guns boomed. A special celebration took place three days later.[9] This began with a salute of thirteen guns at sunrise, and again at noon. This was followed by a parade and a dinner party at the home of Colonel Daniel Tillinghast. When Howland arrived, Colonel Tillinghast asked him to write thirteen toasts for the memorable occasion. He was overcome with surprise at the request, but Colonel Tillinghast persisted, and Howland accepted the task. He immediately realized, however, that he had not only no time to think this important assignment over, as the guests were arriving thick and fast, but there was not even a place for him to sit down quietly and think. So he sat on the stairs, and very soon wrote the following thirteen toasts to be given after the feast was over.[10]

1. The President of the United States
2. The Senate and Representatives of the United States
3. The Governor and Company
4. The Rhode Island Convention that completed the Union of America

5. May the Union last until the Years cease to roll
6. Peace at home and reputation abroad
7. May the Groans of the Distressed be heard no more
8. May America forever honor the men who have led her to the present happy situation
9. Agriculture, Manufacturers, and Commerce
10. The Encouragers of useful arts
11. The Abolition of Party
12. May the Good of the Whole be the great Object
13. May Private Virtue be the road to public honor

After the war, there was an upsurge of interest in the question of general education, and in the last decade of the eighteenth century Howland became converted to the idea of free schools. He came to the conclusion that education was the right of every child, and that it was the duty of the state to provide free public schools. This was advanced thinking, for during the colonial period the prevailing sentiment had been that the education of children was the responsibility of their parents. The well-to-do generally hired tutors for their sons—girls, of course, needed only the rudiments of learning; for them all that was necessary was to learn how to run a house, and the social graces. It was not unusual for parents to form "School Societies," and to provide a schoolmaster to teach in one of the homes of the group; these were called "Neighbors' Schools."[11] To be sure, schoolhouses had been built in almost every town in the colony, but these were not free schools, although occasionally some children were admitted free of charge.

By the end of the eighteenth century the school situation in Providence was not good. The subject of providing adequate schools and schoolmasters had been discussed over and over again, but, in spite of the urging of public-spirited citizens, little had been accomplished. There were five schools in the town—four on

the east side of the Providence River, and one on the west side—but none were free. Two were "Proprietors' Schools," which meant that the school houses themselves were owned by groups of men who leased them to the town. One of these was the "Brick Schoolhouse" on Meeting Street, now the headquarters of the Providence Preservation Society. The other was situated on the north end of Benefit Street on land which had been donated by John Whipple. A third school on Magee Street was a "Neighbors' School," while still another near the south end of Benefit Street was probably carried on by a man in his own home for the benefit of his children and their friends. The fifth school, also a "Neighbors' School," was situated at the corner of Mathewson and Chapel Streets.[12]

In 1785, a committee of leaders in Providence including Dr. Manning, the Brown brothers, and others, was appointed to propose plans for establishing adequate schools, but their plan apparently fell on deaf ears. Six years later the issue came up again, and the committee voted to buy out the proprietors of the Brick Schoolhouse and the Whipple School, and, in addition, to build two new schoolhouses; one at the south end of the city, and one on the west side. No steps were taken to carry out this plan, however, because no funds were provided by the town meeting, either in the form of an appropriation, or by taxation.[13] It was at this juncture that Howland adopted the cause. The more he thought about it, the more convinced he was of the necessity of free education for all Rhode Island children—not only of the most elementary kind, but good enough to "qualify them to be respectable as well as useful members of the Society."[14] Thoughtfully and with determination, he set about getting a law passed by the Rhode Island assembly which would provide for public schools.

It was first necessary to create enough general interest in the matter that would arouse public opinion and

thus put pressure on the assembly. He talked this over with his friends, with his clients, and with the friends of his clients. He wrote more than one article for *The Providence Gazette.* Howland also went to Newport and talked with his friends there in the hope that they would persuade the Newport representatives to vote for this all-important law. He also wrote *The Newport Mercury* to secure its blessing. And of course he preached his sermon to the members of the recently organized Providence Association of Mechanics and Manufacturers. At first, they greeted his proposal with indifference. Howland was surprised because the children of the members of this organization would be among those to benefit by good schooling. It was not long, however, before he won them over, and secured not only their interest, but their cooperation.

A committee of the association was appointed, and met at Howland's house to plan a course of action.[15] He suggested that a memorial be sent in the name of the association to the assembly requesting the passage of a law providing for free schools. All agreed that this was an excellent idea, but none of the members of this committee felt equal to drawing up such an important paper as a petition. Howland then remarked that every man present should write out a petition and then, when the committee met again, ideas could be pooled. In this way a good petition could be written. This was, indeed, a brilliant idea for encouraging the faint-hearted, but it turned out that only two men of the committee really produced a petition—Howland and one other. In the end, the one that Howland had written was voted the better of the two.

Once received by the assembly, the petition was subjected to the usual routine of all petitions—general discussion, then referral to a committee for study before being reported out for a vote. Evidently it received favorable attention, for a bill embodying provision for a

school system throughout Rhode Island was drawn up by James Burrill, the Attorney General, and Howland worked with him.[16] When completed, the bill was so far-reaching that the assembly decided to send a copy to each town to find out the reaction of the general public before a vote was taken by the assembly. Since this was a most unusual procedure, Howland suggested that instructions be sent to each representative to help him in making his decision as to how to vote. This suggestion was acceptable, and that night he sat up half the night writing instructions that were then sent out to the towns.[17]

In the fall of 1799, the House of Representatives voted in favor of the school bill, but the Senate postponed action on it until the next session. This was very disappointing, but Howland was determined not to let the great cause of education perish, and he was able to get the bill placed at the top of the agenda at the next session. By good fortune, when one day he went to the State House to see how his precious bill was faring in the Senate, Howland met Senator John Innes Clarke. In answer to his eager question about the prospects of the bill, Clarke said, "The Governor and Senate are dining with me today, and I will do what I can to secure favorable action on it."[18]

That very afternoon the bill was passed by the Senate without one dissenting vote! How deeply gratified Howland must have been when he heard the news, and how soundly he must have slept that night, happy in the knowledge that, due to his labors, a bright future seemed assured for every boy and girl in Rhode Island. And well might he be proud, because now free schooling for both boys and girls was required by law in every town in the state.[19]

The preamble to the law of 1800, which contains the earmarks of Howland's literary style, seems to us very flowery, but it is worth quoting in that it not only reveals

his strong sentiment in regard to education, but sets forth in clear-cut terms the basic provision of the law which, for the first time, established a public school system throughout the state:

> Whereas the unexampled prosperity, unanimity, and liberty, for the enjoyment of which this nation is eminently distinguished among the nations of the earth are to be ascribed, next to the blessings of Nature, to the general diffusion of knowledge and information among the people whereby they have been enabled to discern their true interest, to distinguish truth from error, to place their confidence in the true friends of the country, and to detect the falsehoods and misrepresentations of factious and crafty pretenders to patriotism, and this General Assembly being desirous to secure the continuance of the blessings aforesaid and moreover to contribute to the greater equality of the people by the common and joint instruction and education of the whole . . . do establish that each town shall annually cause to be established and kept at the expense of the town one or more free schools for the instruction of all white inhabitants between the ages of six and twenty years. . . .[20]

Once the law was passed, the work of implementing it started immediately, and Howland served on more than one committee for this purpose. The three school buildings already being used in Providence were now taken over by the city. New buildings were also constructed on Transit Street, and on Claverick Street. Then came the labor of setting up the administration of the schools and also preparing a general curriculum. Most unexpectedly, Howland found that most of the work on these two important tasks was thrust on him. President Maxcy of Brown University, who was a fellow member of the committee, declared in no uncertain terms that he was too busy as president to have any spare time for anything else, and another man stated that his health would not permit him to spend much time on "desk work."

Howland felt that the cares of the world had now descended on him, but he had no thought of giving up even though he could not help remembering his lack of formal education. While he was deliberating, he suddenly had an inspiration; he heard that two gentlemen were going to Boston, and at his suggestion, the town council asked them to visit the schools there, and obtain a copy of the rules and regulations used in the schools.[21] With these as a blueprint, he drew up a similar set of administrative guidelines for the Providence schools. Howland later asked the Boston school administration for help regarding curriculum, and with the list of books before him, he included not only the tried and true reading, writing, and arithmetic, but added grammar and geography.

His regulations, which included the innovation of prohibiting corporal punishment, were accepted without change by the new school committee, but the requirement to teach geography and grammar was thought to be not only completely unnecessary, but really a waste of time, which could be better applied to the study of arithmetic! Nevertheless, Howland persisted in standing up for these two subjects, and in the end he won.

Four schools in Providence opened in 1800 on a year-round basis—six hours a day from October to April, and six-and-a-half hours a day from April to October—with an enrollment of 988 pupils.[22] From the beginning, the new school system was forward-looking, due in large measure to Howland's broadmindedness. Nor did his interest end when he saw the realization of this project. For the next two decades he watched over the education of Rhode Island boys and girls with heartfelt interest.

Howland soon discovered, however, that his belief in the importance of free schooling for children was not universally shared. Although schools continued to be

maintained in Providence, the outlying towns objected to the expense of teachers' salaries, and of keeping up the schoolhouses. In 1803, therefore, the education law of 1800 was repealed, and for over a quarter of a century free schooling once more languished in Rhode Island. Howland, however, never ceased to preach in season and out of season not only the importance of education for coming generations, but he emphasized over and over again that proper schooling was not just a privilege; it was the *right* of every child and it was the *duty* of the state to provide it.

In 1828 a new school law was passed by the assembly which not only set up a central fund for education, but also permitted towns to raise money for schools by taxation in addition to the old practice of granting lotteries for this purpose. Howland did not really like the new law, but since it meant that once again the state assumed the responsibility for free education, he accepted it and looked forward to the statewide opening of schools once more. He must have taken great pleasure in talking with Henry Barnard, the outstanding educator in New England. Indeed, it was a feather in the cap of Rhode Island that Barnard accepted the call of the assembly to make a survey of the schools throughout the state. He probably felt heartsick when he read Barnard's report on the condition of most schools and their lack of equipment. So much remained to be done! Yet he lived to see the realization in large measure of his goal of free schooling, and to this day Howland merits the title of "Father of Public School Education in Rhode Island."

While his devotion to the principle of free education never diminished throughout his life, Howland was a man of many other interests; cultural, civic and economic. He possessed the rare gift of being interested in everybody and everything, and consequently he played an important part in the life of Providence.

Howland had long been a very active member of the

Providence Association of Mechanics and Manufacturers which had been founded in 1789 "for the promotion of home manufactures, the cementing of mechanics' interests, and for raising a fund to support the distressed."[23] With such a purpose, this association could not fail to appeal to him and he was among the first to join. Howland found both pleasure and inspiration in its many programs and projects. He served on many committees, formally addressed the society three times, acted as secretary for eighteen years, and as president for six years. In 1790 the members of the society sent a congratulatory address to George Washington when Rhode Island ratified the Federal Constitution, and thus at last became a member of the Federal Union.[24] It is not at all unlikely that it was Howland who suggested this gracious act, and he probably composed the address.

He had unquestioning faith in the development of manufactures as one of the cornerstones of national prosperity, and with other members of a committee of the Manufacturers' Association labored to prepare an adequate report, which had been requested by Alexander Hamilton, Secretary of the Treasury, on the industrial conditions in Rhode Island, and the extent of its industries.[25] At his urging and with his help, another document, a protest, was sent to the federal government in 1815 against increased taxation of American manufactured commodities which had for its object increasing federal revenue. It was not long before this obnoxious law, which was felt to place a heavy burden on home manufactures, was repealed, and the members of the association—and Howland in particular—could congratulate themselves that perhaps their efforts in this direction had been worthwhile.

A quarter of a century later the tariff question became an important and serious issue. By this time, Rhode Island was a hive of industry with its textile mills,

its jewelry and silversmithing, and its flourishing metal trades which produced innumerable kinds of hardware needed for machines of all kinds. The prevailing sentiment among businessmen and the members of the Manufacturers' Association was that higher import duties should be placed on foreign goods in order to protect home industry. This was a subject of tremendous importance, and with Howland's help a memorial was drawn up and sent to Washington.[26] Whether this document had any real effect on the lawmakers is not known, but it illustrates his unflagging interest in the welfare of his native state.

Meanwhile, still another business organization had been founded; the Rhode Island Society for the Encouragement of Domestic Industry. Of course Howland was interested, but he was certainly not prepared for the task that was thrust upon him—that of serving on a committee charged with writing the constitution and bylaws of the infant society. And this was before he had even joined this new association! At the same time, he was so familiar with the essentials of a good constitution that he produced the desired paper within a few hours. Some months later, he was asked to be the speaker at the first annual exhibition of the society. Although he declined, the members refused to accept his unwillingness to address the group, and went so far as to publish his name as the speaker in the morning paper. This was indeed a surprise—and not a very welcome one at that—but, since he felt that a refusal to speak would be very difficult to explain without making some critical remarks about the methods used by the members of this association, Howland accepted the inevitable and delivered an address at the exhibition which was held at Pawtuxet.[27]

One of the dominant interests in his life was history, particularly New England history, which was natural, because he was a direct descendent of John Howland, a

passenger on the *Mayflower*. He visited Plymouth many times,[28] and more than once attended special celebrations, like that of "Compact Day." In 1820, at the time of the bicentennial celebration of the founding of Plymouth, he was one of those who heard the immortal Daniel Webster, and, like everyone else, he was lost in admiration of the great man's oratory. When he attended the bicentennial of the landing of the pilgrims in Salem, he gave an address at the banquet that was remarkable not only for its eloquence, but for his clever defense of Roger Williams who, unfortunately, had made many enemies during his five year residence in Massachusetts Bay Colony. For his personal satisfaction, Howland made two more special trips to Plymouth; one for the express purpose of identifying the grave of the first John Howland, the other to have a headstone placed there.

 The Rhode Island Historical Society (the fourth Society of this kind in the United States) was founded in 1822, and Howland became one of its most enthusiastic members. It was not long before he was elected an officer, serving as treasurer for nine years and as president for twenty-three years.[29] The duties of a president of any organization are time-consuming and sometimes burdensome, but at the same time they can be rewarding, and the presidency of the Historical Society was very rewarding for him. Undoubtedly he enjoyed the ever-increasing acquisitions that the society received in its early years; Indian relics, a red coat which had been worn by a British soldier serving in the Revolutionary War; manuscripts, papers, and pamphlets of all kinds, as well as personal papers of Rhode Island leaders of bygone days.

 In addition, his membership in the society proved an open door to wider mental horizons. For several years members of the society and the Northern Antiquarian Society of Copenhagen corresponded on the possibility

of America having been visited by Northmen before the time of Columbus.[30] There was also the puzzle of the mysterious inscriptions on Dighton Rock in Massachusetts, as well as the alluring possibilities of preserving Dean Berkeley's home, and William Coddington's house in his home town of Newport.[31] He kept in touch with the Virginia Historical and Philosophical Society, the American Philosophical Society, the Essex Institute, of which he became an honorary member, and later became a member of the Georgia Historical Society, and The New England Genealogists. Hardly a month went by that he did not write or receive letters from the historical societies of New York, New Jersey, Massachusetts, Pennsylvania, Worcester, and Wisconsin.[32]

With his background of interest in history, he took a keen delight in the celebrations of important events which seemed to march along in an endless procession during the first half of the nineteenth century. One particularly happy occasion was the day-long program of the bicentennial anniversary of the landing of Roger Williams in Rhode Island, which was planned and carried out with the cooperation of the Rhode Island Historical Society and the Providence Town Council.[33] It was held on August 5, 1836, and was started by a salute at sunrise of one hundred guns fired by the United Train of Artillery, and the ringing of church bells for an hour. At ten o'clock a long procession, made up of the United Train of Artillery, the Newport Artillery, the Civic Guards, the Washington Redcoats of North Providence, and numerous city and state dignitaries, and invited guests, marched with colors flying and bands playing from Market Square to the First Baptist Meeting House for a commemoration service. In addition to an oration given by John Pitman, and music performed by some members of the New England Conservatory of Music, Howland read with great feeling a hymn written for the occasion by Albert G. Greene.

The banquet at the Franklin House in the evening, at which Mayor Samuel W. Bridgham presided, included first an "Indian Banquet" which, according to tradition, was served by Miantonomi to Roger Williams on his first visit to Rhode Island.[34] The mayor and the guests therefore partook of a large bowl of boiled bass, and bowls of parched corn, and succotash, while the special item was a bowl of fresh water from the very spring which Williams had found, and which had convinced him that this was the spot where he could live in peace, and worship God as he wished. The day ended with fireworks, and so the celebration, so long looked forward to, was over. Howland must have been very weary that night, but undoubtedly felt a deep satisfaction in the success of the program.

Four other celebrations added color and variety to his life. The first was the semicentennial in 1839 of the inauguration of George Washington as President of the United States, which was held by the New York Historical Society. Howland served as delegate from the Rhode Island Historical Society,[35] and, as one of the speakers, he must have been proud to share the platform with John Quincy Adams. Once more he chose as his theme "Roger Williams," for whom he had a lasting admiration. At this time he also had the joy of visiting Trenton, recalling his service there as a soldier during the winter of 1776-77.

Four years later he was an invited guest of the Massachusetts Historical Society on the two hundredth anniversary of the founding of the New England Confederation which had been formed for the defense of the colonies against the hostile Indians. On this occasion he perhaps experienced some resentment, as well as interest, as he recalled that on account of the hostility of Massachusetts Bay Colony, Rhode Island was never allowed to join the New England Confederation.

In 1847 a commemoration of the centennial of the

annexation of Bristol, Cumberland, Little Compton, Tiverton, and Warren to Rhode Island was suggested by the historical society, and it is safe to assume that Howland was the godfather of the idea.[36] The celebration took place at Stone Bridge in early July. Although this time he was not a speaker, he enjoyed the colorful ceremony in spite of a long and tiresome sail back home. Within a week or two, he was in Newport to take part in the commemoration of the hundredth anniversary of the founding of the Redwood Library.[37] His pleasure must have been partly nostalgic, as he thought back to his childhood days in the old town. At the same time his heart must have been filled with gratitude that, at last, after the terrible years of the occupation of the town by the British troops during the American Revolution, Newport was returning to its former prosperity as a summer paradise for visitors.

During the first quarter of the nineteenth century, two movements for the betterment of mankind—world peace and temperance—aroused a great deal of interest in this country, and both men and women worked enthusiastically for these great causes. It was natural that Howland should take his stand under both banners. Although he had fought in the American Revolution, he detested war—its cruelties, wastes, and uselessness, and he looked forward with almost childlike optimism to the halcyon day when this means of settling disputes between nations would be abandoned forever. He joined the Rhode Island Peace Society and became one of its trustees, as well as serving as president for fourteen years.[38] His hopes for world peace were raised in 1843 by the first Peace Convention that was held in London "to promote universal and lasting peace."[39] Had it been possible, Howland might have gone to England for the convention, but as he was by this time no longer young, such an extended trip would have been unwise.

The Temperance movement appealed equally to him, because he had always decried the extensive use of spirits by all classes. He felt so strongly about the evils of drunkenness that he determined to take positive steps to combat the deleterious effects of alcohol on the health and fortunes of his fellow men. In 1837, encouraged by growing public opinion in New England in the direction of temperance, he called a meeting of broad-minded citizens in his office to launch, if possible, this much-needed reform. He presided at the meeting, and, of course, no one could oppose the fine purpose of his effort. Other meetings followed, and, at length, various resolutions became embodied in a pledge "to abstain from the habitual and unnecessary use of ardent spirits."[40]

Because he wanted the cause of temperance to be adopted as widely as possible, he turned again to his old friends—the members of the Mechanics and Manufacturers Association. A committee of which he was a member was appointed, and resolutions were adopted not only to urge the habit of temperance among the members of the organization, but to try to influence workmen of all trades along the same lines. Thus the Temperance movement gradually strengthened and expanded in Rhode Island. Once more the public-spirited John Howland labored in behalf of the betterment of his fellow citizens.

Although he was closely associated, week in and week out, with the many programs and projects of the Mechanics and Manufacturers Association and with the administrative duties of the Rhode Island Historical Society, which fanned out like the spokes of a wheel into all kinds of different activities, for many years he occupied two other quite different posts. One was that of City Auditor, later renamed City Treasurer. The other was that of Treasurer of the Old Stone Bank which had been founded largely through the interest and efforts

of his fellow members of the Mechanics and Manufacturers Association. Because he had been forced to rely on his own labor for his livelihood and for the support of his family, he had early recognized the importance of ready funds that could be drawn upon in case of emergencies. He enthusiastically seconded the pleas of his fellow members of the assocation. He attended a general meeting of prominent citizens called to discuss the possibilities of a savings bank and was pleased when offered the position of Treasurer. He continued in this position for twenty-one years,[41] and watched with great interest the steady growth of the capital funds of the bank through individual savings. He was also deeply gratified about the savings of many of the members of the association who, like the good fairies in the old tale, had "danced around the cradle" of the infant Old Stone Bank.

Although he officially retired in 1840 from active participation in his many pursuits, he had almost a decade-and-a-half yet to live. Apparently the years of leisure were happy ones during which he could attend the meetings of the organizations to which he belonged without the burdens of official responsibilities and could take part in the celebrations of historical events of importance. During these years, he could also enjoy his grandchildren and their friends and could tell them stories of the "good old days." Probably one of his most colorful tales was that of his friendship with Paul Revere, whom he had met as a member and president of a sister organization, the Massachusetts Charitable and Mechanics Association. Revere had visited Providence more than once, and he was always a house guest of the Howlands when he came.[42] Howland especially liked to relate the story that when he was a guest of the triennial anniversary of the Boston Mechanics Association, he had proved a worthwhile ally of Revere's, who after the banquet (to his complete surprise) was called upon to

say the inevitable "few words." For a moment he was at an utter loss, but Howland came to his rescue. He had prepared two toasts "just in case" which could be used in almost any circumstance. One of these he hastily passed over to Revere, who then bravely stood up and concocted a short address which was received with applause.

Howland lived to be almost one hundred years old, dying at the age of ninety-seven. Of course he had seen tremendous changes during his life; indeed at times he must have wondered more than once if he was living on the same planet as that on which he had been born. When the teenager John Howland had come to live in Providence, Rhode Island had been a British colony. Now in the middle of the nineteenth century it was a highly industrialized state in a rapidly growing nation. Gone were Indian paths and dusty roads; railroads now connected Providence with Boston, Worcester, and New York, and two steamboat companies provided daily steamboat trips to New York. Because of the steep hill on the east side of the Providence River, the west side had become the business section of the city and was crisscrossed with side streets and two main thoroughfares. The Brown University campus which crowned the summit of College Hill now had four buildings instead of one. University Hall, which for over fifty years had served as classroom, library, and dormitory for the students, was flanked on the north by Manning Hall and Hope College, the college dormitory, and on the south by a science building, Rhode Island Hall.

For Howland, probably the most important change was the expansion of the school system which he had watched with unceasing personal interest. He had lived to see forty-eight schools in operation in Providence instead of the four which were opened after the passage of his law in 1800. The corps of teachers had been increased from nine to 112 and the 988 children who had

been enrolled in the first year now numbered six thousand. He could congratulate himself that his faith in free public education had been justified.

John Howland was one of the outstanding men in his generation; born in humble circumstances, having had little or no schooling, carrying on an unaristocratic trade, he worked hard to gain a position of respect and admiration. While the brightest star in his crown was his contribution to free education of Rhode Island boys and girls, at the same time he had given freely of his time, strength, and abilities to the cultural and civic well-being of Providence.

That he stood high in the esteem of his fellow citizens is evidenced when Brown University awarded him, in 1835, the honorary degree of Master of Arts. It probably was the proudest moment of his life when, with other scholars, he received his diploma. But John Howland himself was a scholar and a gentleman.

Notes

1. Edwin M. Stone, *Life and Recollections of John Howland*, p. 16.
2. *Ibid.*, p. 18.
3. *Ibid.*, p. 15.
4. Arnold, *History of Rhode Island*, II, 312.
5. Stone, *Life of Howland*, p. 50.
6. *Ibid.*, p. 56.
7. *Ibid.*, p. 72.
8. *Ibid.*, p. 106.
9. Edward Brooks Hall, *The Life and Times of John Howland*, p. 14.
10. Stone, *Life of Howland*, p. 165.
11. Charles Carroll, *Public Education in Rhode Island*, p. 57.
12. *Op. cit.*
13. *Ibid.*, p. 55.
14. Thomas Wentworth Higginson, *History of Public Education in Rhode Island*, p. 150.
15. Stone, *Life of Howland*, p. 140.
16. The preamble of the memorial which was sent to the Rhode Island General Assembly has become famous in the annals of public education:
 That the means of Education which are enjoyed in this State are very inadequate to a purpose so highly important; that members of the rising generation, whom God has liberally endowed are suffered to grow up in ignorance, when a common education would qualify them to act their parts in life with advantage to the public and reputation to themselves; that in consequence of there being no legal provision for schools . . .
 See Carroll, *Public Education in Rhode Island*, p. 77.
17. Stone, *Life of Howland*, p. 142.
18. Higginson, *History of Public Education in Rhode Island*, p. 153.
19. *Op. Cit.*
20. Carroll, *Publication Education in Rhode Island*, p. 80.
21. Stone, *Life of Howland*, p. 147.
22. Carroll, *Public Education in Rhode Island*, p. 61.
23. Edwin M. Stone, *Sketch of the Origin and Early History of the Providence Association of Mechanics and Manufacturers*, p. 31.
24. Higginson, *History of Public Education in Rhode Island*, p. 238.
25. Stone, *Life of Howland*, p. 175.
26. *Ibid.*, p. 181.

27. *Ibid.,* p. 220.
28. *Ibid.,* pp. 130-33.
29. Correspondence and Reports of the Rhode Island Historical Society, Rhode Island Historical Society Archives, vols. I-IV, 1834-54.
30. *Op cit.*
31. *Op. cit.*
32. *Op. cit.*
33. Stone, *Life of Howland,* p. 260.
34. *Ibid.,* p. 262.
35. *Ibid.,* p. 264.
36. Correspondence and Reports, vol. II.
37. Stone, *Life of Howland,* p. 286.
38. *Ibid.,* p. 206.
39. *Ibid.,* p. 207.
40. *Ibid.,* p. 227.
41. *Ibid.,* p. 215
42. *Ibid.,* p. 196.

Bibliography

Primary Material

Correspondence and Reports of the Rhode Island Historical Society. Vols. I-IV, 1834-1854. Rhode Island Historical Society Archives.

Stone, Edwin M. *Sketch of the Origin and Early History of the Providence Association of Mechanics and Manufacturers.* An Address delivered at the Seventy-first Anniversary, 1860, Knowles, Anthony and Company, 1860.

Secondary Material

Arnold, Samuel Greene. *History of the State of Rhode Island and Providence Plantations.* 2 vols. D. Appleton & Company, 1860. Vol. II.

Cady, John H. *The Civic and Architectural Development of Providence, 1636-1950.* Ackerman Standard Press, 1957.

Carroll, Charles. *Public Education in Rhode Island.* E. L. Freeman Company, 1918.

Hall, Edward Brooks. *The Life and Times of John Howland, a Discourse delivered before the Rhode Island Historical Society,* February 6, 1855. George H. Whitney, 1855.

Higginson, Thomas Wentworth. *History of Public Education in Rhode Island, 1636-1876.* Ed. by Thomas B. Stockwell. Providence Press, 1876.

Stone, Edwin M. *The Life and Recollections of John Howland, Late President of the Rhode Island Historical Society.* George H. Whitney, 1857.

A Portrait Album

Elizabeth Buffum Chace

Elizabeth Buffum Chace

The United States was still a young nation when Elizabeth Buffum was born in Providence, Rhode Island on April 9, 1806. She was the second daughter of Rebecca and Arnold Buffum, and it was not long before three more girls and two boys were added to the family. Elizabeth's parents were staunch Quakers of New England stock; her mother's family had settled in Newport in 1637, while the Buffums, after living for some years in Massachusetts, had removed to Smithfield, Rhode Island, in 1715.

Little Elizabeth could be called something of a child prodigy, for she seems to have attended a school at the age of two or three, and about three years later she used to read the reports of the Proceedings of Congress printed in the *Manufacturers' and Farmers' Journal* to her father and grandfather while they were having breakfast.[1]

According to today's thinking, her schooling was somewhat irregular. For a year or two she and her older sister attended a public school in Connecticut, where their father had settled while attempting to rebuild his fortunes after business reverses. It was during these years that Elizabeth began to understand the sharp differences between her Quaker precepts and beliefs and those of other faiths.

Somewhat later, when she was a teenager, she became a boarder at the Friends' School in Providence. Life was real, life was earnest at the Friends' School in those days. There were classes before breakfast, and classes after supper. No celebrations or holidays added variety to the days and weeks of study; no music was played to cheer the heart; no pictures were hung on the walls or sculpture set in the rooms to feed the soul with beauty. And finally, the girls were not allowed to curl their hair,

to wear any jewelry, or to trim their dresses with ruffles, ribbons, or lace.[2] Spiritual beauty aplenty, perhaps, but to us today it seems a drab and uninspiring background.

Meanwhile, her father had become interested in the textile business and had moved his family to Fall River. There Elizabeth met another Quaker, Samuel Buffington Chace, who she later married in 1826. With her Quaker background she was naturally opposed to slavery as an institution, but she developed a very deep interest in the abolition of slavery when in 1832 her father was chosen as the first president of the New England Anti-Slavery Society.[3]

It was at this time that the slavery question began to loom larger and larger in the country. Curiously enough, although New Englanders as a whole probably were opposed to the institution of slavery, at first there existed an almost universal restraint in taking any steps against it, or even in openly discussing the problem. There were several reasons for this. For one thing, New England was enjoying an intellectual Indian summer,[4] and under the literary leadership of William E. Channing, Emerson, Whittier, Longfellow, and others was absorbed in discussions of Transcendentalism, Unitarianism, and Humanitarianism, as well as in experiments in plain living and high thinking such as were being carried on by Bronson Alcott at "Fruitlands," Thoreau at Walden Pond, and at the Reverend George Ripley's Farm in West Roxbury. Secondly, the rapidly growing textile industry was dependent on cotton from the South, and any drastic change in the labor conditions there would vitally affect the pocketbooks of the textile manufacturers. To both of these reasons was added a third—perhaps the most important of all—the fear that an attempt to force the abolition of slavery on the South would result in the dissolution of the Union.[5] Life without the Union was unthinkable!

Consequently, it took great courage for anyone—man

or woman—to come out openly against slavery. But both Mr. and Mrs. Chace had great courage as well as unshakable convictions on the subject. They early joined the band of dedicated workers enrolled under the banner of William Lloyd Garrison, whose newspaper, *The Liberator,* sounded the battle cry in 1832. "I am determined at every hazard," he wrote in the first issue, "to lift up the standard of emancipation in the eyes of the nation I am in earnest—I will not equivocate—I will not excuse—I will not retreat a single inch—*AND I WILL BE HEARD!*"[6]

The first step was to awaken the public conscience on the curse of slavery, and Mrs. Chace, although a busy wife and mother, worked in and out of season to secure speakers and arrange meetings to explain the heartbreaking plight of the negroes. Of course, it was not always easy to whip up enough interest to produce good audiences. In 1835, the Ladies Antislavery Society was organized in Fall River, and in the following year Mrs. Chace became its first vice-president.[7] The main weapon, for women at any rate, was the anti-slavery petition begging the federal government to do away with the detestable institution of slavery. These were signed by as many people as possible and then sent to Congress. Mrs. Chace was a firm believer in the petition, even though many New Englanders refused to sign since slavery was allowed by the Federal Constitution, and many were the miles she trudged from door to door trying to secure signatures.

It was really fortunate that she had the cause to work for because in the early days of the antislavery agitation, she and her husband suffered some heart-rendering experiences. Not long after their marriage in 1826, a son was born to the happy couple, and later four more children arrived to delight their parents. Then their happiness was turned to overwhelming sorrow as one by one all five children died within a few years of each

other, and their home, which at one time had been filled with children's laughter and the sound of running feet, was now empty and silent.[8]

Mr. Chace's textile industry failed in the hard times of 1837, and after a while he moved from Fall River to Valley Falls, Rhode Island to begin again. Both Mr. and Mrs. Chace became active in the "underground railroad." This was very dangerous, but neither of them hesitated to harbor runaway slaves in their home and help them on their way to Canada. Mrs. Chace was always full of anxiety for their safety, not only in her house, but during the rest of their journey to freedom, and she devised a scheme by which she would eventually learn of their arrival in Canada. She gave the man or woman who had stayed a night or two with her a stamped, self-addressed envelope which was to be mailed back to her.[9] There was no need for a message—and in any case very few negroes could read or write—just the envelope postmarked "Toronto" told the story, and she was full of joy when one by one most of these envelopes did come back.

While Mrs. Chace was involved in the great struggle, she enjoyed meeting and working with the leaders of the antislavery movement—William Lloyd Garrison, the most important of them all, Wendell Phillips, Thomas Wentworth Higginson, Lucretia Mott, Lydia Maria Child, and many others. She admired all these fine men and women, and built friendships with them which she maintained as long as she lived. She also knew the remarkable Grimké sisters, but apparently was never intimate with them. During these years Mrs. Chace never appeared on a public platform; for one thing she shrank from publicity, and then, too, before the Civil War public opinion was decidedly against women who had the temerity to rise in an assembly and speak on any subject!

She was surprised and indignant to learn that the

Quakers in general had not joined with the abolitionists in the fight for the freedom of slaves. In fact they often refused the use of their meeting houses for abolitionist meetings. This she could neither understand nor accept; finally, after some years of smouldering anger about this strange attitude, she resigned in 1843 from the Society of Friends into which she had been born and had been taught to revere. She remarked some time later that "When the Friends shut the slave out of their religious houses, they shut me out."[10]

Although these were dark days for the nation, both Mr. and Mrs. Chace counted themselves more than doubly blessed, because five more children were born to them—three boys and two girls—and once again they could enjoy the delights and responsibilities of parenthood.

The Chaces and their fellow workers continued the battle against slavery for thirty years which, as time went on, became more and more desperate. It was hard not to be discouraged when there seemed to be no light at the end of the tunnel, and several events—mob violence in Boston, the beating of Charles Sumner in the Senate Chamber, and John Brown's Raid on Harper's Ferry —demonstrated the increasing animosity between the North and the South. There appeared to be no way to prevent the dissolution of the Union, which would inevitably mean war.

Like most abolitionists, Mrs. Chace had no great liking for Lincoln, because he did not take a firm stand on the slavery question. And because of her Quaker upbringing, she felt that all war was wicked, and therefore she could only hate the Civil War in spite of the vitally important issue of the freeing of the slaves. At times she even thought that the eventual defeat of the North, should it come, would serve as a valuable lesson on account of its apathy towards slavery.[11]

When the war was finally over, she seems to have felt

no great joy that the North was victorious, since the question of the future of the negroes still remained unresolved. Although they were now technically free, their problems would never be really solved until racial and political equality with the whites was secured. For a few years the National Antislavery Society continued to exist, but now that the great goal of emancipation had been reached, interest in the society gradually dwindled until it was dissolved in 1870. Mrs. Chace realized that many problems had been left unsolved, even though slavery was a thing of the past, but she turned her attention to other things, and she found plenty to do at her doorstep.

She had long wanted to add some interest to the drab lives of the workers in the Blackstone Valley mills. Now, with the help of some of her neighbors, she started some evening schools for all workers, and took upon herself the task of securing volunteer teachers.[12] At about the same time, she carried on in her own home a sewing class for girls who worked in the mills, and in addition, she and Mr. Chace set up a general reading room for both men and women, and provided books and magazines which they hoped would interest them. Then, by chance, she learned of the success of an amusement room for boys in Boston which had been started for the purpose of keeping them off the streets at night. As soon as possible, she procured a recreation room for boys in Valley Falls and persuaded some volunteers to maintain programs. Mrs. Chace promised to preside on Saturday evenings.

Some years later, she embarked on still another project—a kindergarten for children whose parents were busy in the factories all day. So enthusiastic was she about the value of kindergarten training that she supported the little school for seven years.[13] She endeavored to get the town council to include kindergartens in the school system, but was not successful, and at length

the doors of this school were closed for good.

While she was thus playing an active part in the life of the countryside, she was also deeply interested in two issues of world importance; the National Peace movement and temperance. Never content to be merely a member of a group or organization whose aims and purposes appealed to her, it was not long before Mrs. Chace was planning discussion groups in her neighborhood with invited speakers on the inspiring subject of world peace. She also travelled to Providence to attend meetings, and it was through her help that the Friends' Meeting House there was opened for peace meetings.[14]

Mrs. Chace was equally interested in the cause of temperance and joined a committee of women who were daring enough to go into liquor stores to try to induce the owners not to sell intoxicating liquors. This campaign was a total failure, however, for their pleas were met by the flat statement that liquor licenses had been granted by the town council to carry on this trade. Mrs. Chace and her friends then went to the source of the problem; they attended the town council meetings more than once to argue against granting liquors licenses.[15] Here they made some headway, for gradually liquor licenses were not issued so freely. She even went a step further in her crusade by organizing year round Sunday afternoon temperance meetings, and prevailed upon her son Sam, now a college student, to gather together a group of young men as members of the Sons of Temperance. This was no easy task, but it turned out to be fairly worthwhile.

For Mrs. Chace a new chapter in her life began in 1868. With her deep and unchanging belief about justice in all cases and for all human beings, she had long realized that the position of women as citizens was inferior to that of men. In 1850 she attended a convention on this matter in Worcester, Massachusetts. At that time, however, the controversy over freedom for the slaves

was reaching its height, and therefore, as far as she was concerned, women's rights had to be pigeonholed.

In October 1868, Mrs. Chace with her friend Mrs. Paulina Wright Davis, attended a convention in Boston when the New England Woman Suffrage Association was founded. They came back to Providence fired with enthusiasm for the future which seemed to hold glowing possibilities for upgrading the position of women, and they decided to organize a Woman Suffrage Association in Rhode Island.

They went to work at once. Letters were written to their friends, both men and women, and to the friends of their friends explaining the importance and the urgency of the Woman's Rights movement, and a house-to-house canvass was made to arouse interest in the great cause. The following notice was inserted in *The Providence Journal* every day for a week, "The undersigned invite their fellow citizens of Rhode Island to meet with them in Convention in ROGER WILLIAMS HALL on Friday, December 11, 1868, at 10 A.M. to consider the rightfullness and importance of extending the elective franchise to women."[16] It was signed by forty-eight prominent women and men who believed that it was the duty of the state to allow women to vote. One of the most interesting signers was Sarah Helen Whitman, the Rhode Island "Poetess," who was greatly admired in her day. She had been courted by Edgar Allen Poe, but eventually their engagement had been broken off.

The convention turned out to be very encouraging to both Mrs. Chace and Mrs. Davis and their friends. Many people attended, and several well-known speakers were listened to with thoughtful attention. William Lloyd Garrison had been invited to make an address, but, unfortunately, bad health forced him to decline. However, Frederick Douglass, the famous black man who had been born in slavery and who had later become a friend of Abraham Lincoln, lent great prestige to the meeting.

Mrs. Chace, who had by now overcome some of her shyness, presided at the convention, and also gave an address.

The Rhode Island Woman Suffrage Association was organized at the meeting with its fundamental purpose of securing the political franchise for women.[17] Mrs. Pauline Wright Davis was chosen as its first president, and Mrs. Chace became the chairman of the executive committee. Full of optimism that it would be a relatively easy task to get the franchise for women by means of an amendment to the State Constitution, the members set up a clear-cut program. The goal, of course, was to secure the amendment, but the question immediately arose as to how to go about it. Mrs. Chace remembered the petitions against slavery that had been sent to Congress, and she suggested that this might be a good approach. Signed petitions, therefore, became the first tool used, and the first petition, with an impressive list of signatures of both men and women, was sent to the Rhode Island legislature in 1869 in time for its meeting in October.

Very soon after the suffrage association came into being, Mrs. Chace was faced with an extremely difficult decision. As a believer in the political equality of negroes and whites, she had long been a member of the Equal Rights Association and had worked for the extension of the vote to the negroes. She was pleased when this right was embodied in the fifteenth amendment to the Federal Constitution which had recently been introduced into Congress. Now, Mrs. Elizabeth Cady Stanton, President of the American Women Suffrage Association, advocated opposition to this amendment because, she declared, it would mean a setback for women, since it would bestow the right to vote on more males while this right was still denied to women. Mrs. Stanton had won over Mrs. Paulina Davis to her thinking, and Mrs. Davis in turn tried to influence Mrs.

Chace to turn her back on one of her fundamental principles in regard to the negro problem. What was she to do? Such a drastic change of mind could not be made easily, as, for instance, deciding on a hat, or to trim a dress with this or that piece of lace. After weighing the arguments for several days she realized that her conscience would not permit her to abandon a conviction she had held for many years. She declined unequivocally to urge the members of the Rhode Island Woman Suffrage Association to oppose the fifteenth amendment, and, as she succeeded Mrs. Davis as president in 1870, her attitude undoubtedly did a great deal to enroll Rhode Island women in its favor.[18]

She took up her duties as president with enthusiasm, but that year was one of sadness for her, personally, because her husband, Mr. Samuel B. Chace, who had been in failing health for some time, died in December. Tragedy struck again six months later, when her second son, Edward Gould Chace, who had suffered for several years from an obscure disease, died at the age of twenty-two.[19] He had been a young man of great promise, and his mother found it hard to bear this second cross of sorrow.

The suffragists never lost sight of their fundamental goal—the enfranchisement of women—and under the leadership of the new president they began to learn about the basics of the problem. During the first years, they heard lectures at their monthly meetings on every conceivable angle of the status of women; their legal and political rights—or lack of them—not only in Rhode Island, but in every state in the Union, and also in Europe. It was only occasionally that the meetings were lightened by musical programs, and sometimes during the early weeks of summer a strawberry festival would add a festive note to their crusade.

Although their signed petitions pleading for the amendment to the State Constitution met with no re-

sults, it was not long before the members of the association began to work for the elevation of the position of women in general by seeking to have them included on an equal basis with men in various state activities. This was not accomplished easily or quickly, but by degrees the tide began to turn, and through the efforts of Mrs. Chace, some progress was made in one field—the administration of the state institutions. For some time she had thought that women should hold certain positions in the state penal and charitable institutions in which women were incarcerated. She had visited the state prison more than once and decided that although the women's quarters were clean and the matron seemed kindly, the board of managers of the prison should include in its membership women whose duty should be to watch over and report on the care of the women inmates.

She had a memorial prepared and sent to the Governor of Rhode Island which was endorsed by the members of the suffrage association. It stated the need for "intelligent, judicious and humane women [to be] placed on the Boards of Inspectors of the State Charities and Corrections" and concluded that "the time has come when greater enlightenment requires that women should be allowed to do their share of the duties of Inspectors."[20] The memorial requested that three women should be appointed on the board of inspectors of the state prison, and also on the board of state charities and inspections.

At first, the wording of the existing law in regard to the membership of the board of inspectors presented legal difficulties in granting the request, but after a good deal of delay the legislature solved the problem by creating a new board—a Board of Lady Visitors. Although they had no authority to enforce or change rules, they were supposed to visit and inspect all the state penal institutions in which women were confined.

It was a foregone conclusion that Mrs. Chace would be the first woman appointed by the governor on the new board. She was not completely satisfied with the outcome of her efforts, since the board was granted no real power; nevertheless, it was a step in the right direction. She accepted this responsibility seriously and served on the board for several years, faithfully visiting the prison from time to time.

She went as a delegate to London in 1872 to attend an International Congress on the Prevention and Repression of Crime. Her old friend, Julia Ward Howe, was another delegate, and Mrs. Chace enjoyed being with her and being included in the acclaim which was given to the famous authoress of "The Battle Hymn of the Republic." At one meeting of the Congress she read a paper on the importance of women serving on boards of inspectors, prisons and almshouses, and at the conclusion of the conference she made an extensive tour of the continent, travelling to France, Switzerland, Italy, and Germany. True to form, she combined business with pleasure by visiting prisons, almshouses, asylums, and other institutions, as well as the great art galleries, and sites of historical interest. Her inspection of the prisons added to her understanding of the problems of prison administration.

Home again, she was soon absorbed in the duties and responsibilities as president of the suffrage association. Memorials to the legislature with regard to the amendment to the State Constitution giving women the vote continued to be sent year after year, and at the hearings qualified men and women urged its adoption. Year after year, however, the petitions died in committee, or were voted down. Once, when the memorial was apparently cast into the wastebasket by the judiciary committee without even the courtesy of a reply being sent to the members of the association, Mrs. Chace and the others protested publicly against this indignity.[21]

Meanwhile, the second objective of the suffragists—a more important role for women in Rhode Island—had not been forgotten. Two years after her return from Europe, Mrs. Chace launched a drive for the appointment of a matron, and an assistant matron in the police stations in Providence.[22] At first, this seemed a shocking idea, a possibility almost beyond the thinking of the times. A woman on duty in police stations! What would she see; what duties would she be called on to perform! Those most opposed to this were the members of the police force who declared that women should not be asked to serve in this capacity, because most of the women who were brought into the police stations were drunk. Furthermore, they argued that it would probably be impossible to secure women who would be willing to perform the necessary duties.[23] As always, Mrs. Chace sought to bolster her recommendation by writing an article in *The Providence Journal* in which she said; "In behalf of our falling and fallen sisterhood, I would appeal to the City Government for the appointment of a Matron and an Assistant Matron in every Police Station in the City. They should be women of good character and judgment, and such provision should be made for their comfort that suitable women would be induced to accept such positions"[24]

Such a startling innovation took more than ten years to be accepted, but eventually, in 1886, to be exact, the Providence Town Council passed an ordinance requiring the appointment of a matron in every police station in the city. Mrs. Chace felt that this was a milestone in the uphill struggle to gain the equal position of women with men. Furthermore, she was now confident that when women were taken to the police stations, whatever their condition, they would be properly cared for by a woman. She was also very proud that Providence was the first city in the United States to take such a progressive step.

During the period when she was serving on the Board of Lady Visitors of the State Prison, she regularly visited the reform school, and she became greatly distressed about conditions there.[25] She discovered that the school, far from *reforming* a boy or girl who had been placed there, in reality provided newcomers or younger children with instruction in crime. And some of the older boys and girls were well versed in the techniques of committing crimes. Worst of all was the situation with the delinquent girls, because for some reason many of those who had returned to the outside seemed unable to look out for themselves. Sooner or later, they would get into trouble, and would have to be sent back to the school. Mrs. Chace believed that the best way to "reform" the reform school was to house the boys and girls in separate buildings with a supervisor for the boys and a matron for the girls. She further urged that teachers in various subjects be appointed to prepare the inmates for living as decent, law-abiding citizens when they were old enough to go out into the world. This objective was not attained for some years, but she never forgot it and never gave up working for it.

In 1882, she was at last rewarded by a vote of the legislature to carry out her proposal. Two houses, each equipped with classrooms, were built in Cranston on land belonging to the State.[26] The girls' home was called "Oaklawn" and the boys' building was given the Indian name of "Sockanosset." Thus, the basic problem of the reform school was solved, and the old reform school ceased to exist. Mrs. Chace was gratified when the buildings were completed and added Oaklawn and Sockanosset to her list of places to be visited. To help along the good work of providing pleasant living conditions for the boys and girls, she gave some musical instruments to Sockanosset so that the boys could organize a brass band, and was planning to donate a piano to Oaklawn when she learned that a parlor organ had

already been sent there.

Meanwhile, she had discovered another group of children who needed help—perhaps these were the saddest of all. They were children who could not be assigned to Oaklawn or Sockanosset because they had not been convicted of any crime, but they had no homes because their parents either could not or would not support them. She found that she could not forget these waifs, and she longed for a home and school that could give them some degree of happiness under proper supervision, and also where they could be educated so that they would grow up to be good citizens. As before, she sought the interest and support of the general public for a state home and school by writing more than one article in *The Providence Journal.* She put the case very plainly by saying: "Believing as I do that God sends into this world no human soul which has not in it the possibilities of a pure and virtuous character, it was natural that I should see that a grave responsibility rested somewhere for the proper education of these children thus thrown upon the guardianship of the State"[27]

As she expected, she encountered opposition and delay, both on account of the apathy of the public, and also because the legislature hesitated for a long time before it was willing to appropriate funds to build and equip such an institution. Then when the members of the legislature did begin to discuss the problem, another delay ensued over the question as to where the home and school would be built. Mrs. Chace was opposed to having it placed on the property of the state institutions both on account of the stigma that would be attached to the boys and girls after they left the school for good, and also because she did not think it was wise for the children's parents, many of whom were either serving terms in prison, or who were living in the almshouse, to be able to contact their children easily and often.

At last the race was won when the legislature voted in

1884 to build a state home and school on the outskirts of Providence. Mrs. Chace was pleased with the choice of the site; it was not on state property, but it was not very far from the state institutions, and she felt sure that the children would be happy living in the country. She could not quite understand why the school had been placed under the jurisdiction of the state Board of Education, but at first everything seemed to be going along smoothly, and her semi-annual visits to the school were both pleasant and worthwhile.

Gradually, however, she began to hear rumors that Mr. Healy, the superintendent, was using very harsh, if not cruel, methods of discipline on unruly boys. Indeed, she hated to get drawn into such an unpleasant situation, as she was no longer a young woman. On the other hand, she had always felt a special responsibility for the welfare of the boys and girls living at the state home and school. Therefore, she decided that an investigation *must* be held by the state not only into the character of Mr. Healy and his methods of dealing with the boys and girls, but it must also include looking into the listless supervision of the school by the Board of Education.

She attended the trial of Mr. Healy and gave her testimony against him in no uncertain terms. This was listened to with great respect, not only on account of her prestige as a philanthropist, but also because of her wide knowledge of the administration of the state institutions in general, and of the state's care of children in particular. The outcome was to be expected; the superintendent and his wife were dismissed, and a new couple were installed in their place. A year or two later, the Board of Education was relieved of its responsibility for the school. A new board consisting of four men and three women was then established to take charge of the administration of the state home and school.[28] Mrs. Chace and her little band of suffragists were gradually succeeding in enlarging the opportunities for women in

civil life.

While her efforts towards bettering conditions at the reform school, and later providing for dependent children demanded a great deal of her time and strength, Mrs. Chace never lost sight of the basic purpose and activities of the Woman Suffrage Association. She conducted the meetings of the executive committee year in and year out as well as the general meetings of the organization. It was a rare season indeed that she did not give a paper on some pertinent subject at one of the general meetings, and she always helped to organize the program of the annual convention as well as serving as the presiding officer.

In 1882, she had a brilliant idea for adding interest to the convention of the suffrage association. She requested permission to hold it in the State House in the Hall of Representatives. It was not surprising that this was refused; the excuse given was that the law expressly stated that this room was for the use of representatives only.

This was discouraging, but Mrs. Chace was accustomed to having her requests refused. Undaunted, she tried again two years later, and this time her wish was granted, and the convention held in 1884 was unusually successful. It must have been a proud moment for her as she stood up to call the meeting to order, and one of the Providence newspapers reported that, "The President, Mrs. Elizabeth B. Chace presided over the exercises with grace and dignity, the desk being beautifully decorated with clusters of flowers and trailing smilax."[29] She welcomed the men and women gathered in the Hall of Representatives by saying, "Friends, I bid you welcome this morning to this house. We have come here hoping to leave behind us an inspiration that shall affect for good whatever may be done hereafter within these walls concerning the interests, the rights, and the duties of the women of our State."[30]

She introduced the various distinguished speakers who had come to Providence to attend the convention; Miss Susan B. Anthony of national fame who was in truth the "First Lady" of the suffrage movement, the venerable Frederick Douglass, William L. Garrison, Jr. and others. Mrs. Elizabeth Cady Stanton, President of the American Woman Suffrage Association, who was unable to attend, sent a special greeting, and Mrs. Chace herself gave an address at one of the sessions. The Chamber of Representatives was packed to the doors, and it was necessary to open up some of the side rooms, and to ask the speakers to deliver their addresses a second time to those who had not been lucky enough to gain seats in the main room.

After more than ten years of frustration in trying to induce the members of the Rhode Island legislature to vote in favor of an amendment to the State Constitution granting political rights to women, the suffragists thought that the Promised Land was in sight when the Senate passed a resolution in February 1886 to submit this amendment to the voters. Of course, this was very exciting news, but it was only half a step forward, because the resolution had to be passed by the House of Representatives at its next session, and then passed all over again by the next legislature. In other words, the amendment—any amendment to the State Constitution—was required by state law to be ratified by the two legislatures before it could be presented to the voters for approval.[31]

At first, everything went along smoothly, for at its May session the House of Representatives voted in favor of the Senate resolution. Mrs. Chace was overjoyed when she heard of this and said, "My heart swelled with fervent thanksgiving, the ground seemed firmer under my feet, my faith in the justice of Rhode Island men grew strong, and life devoted to human progress seemed really worth living."[32] Then, the second test was

successfully passed, and a copy of the amendment which read, "Women shall have the vote in the election of all civil officers and on all questions in all legal town, district, or ward meetings, subject to the same qualifications and conditions as man," was sent to every town and ward meeting.[33]

Even so the fight was not yet won, as the ladies soon discovered. The date for the voting was set for the first week of April 1887, and this gave them only *one* month to persuade the Rhode Island voters to vote for its passage. It turned out to be a blistering campaign. Headquarters were set up in the Butler Exchange in downtown Providence, and the members of the suffrage association worked all day, every day, and far into the night to get out a favorable vote. Mrs. Chace was in the center of the battle, planning the tactics, writing articles for the newspapers, and helping to keep up the morale of the workers. Meetings were organized in every town in the state, and well-known speakers as, for instance, Julia Ward Howe, were urged to "come over to Macedonia and help us."

It was disheartening to discover that the Rhode Island press, in general, was not in favor of the amendment. Every day during the crucial month before the referendum, *The Providence Journal* carried articles and editorials urging the defeat of the voting privilege.[34] To combat this barrage of opposition, the suffrage association hired equal space in the *Journal*, and produced articles and editorials beseeching the voters to vote in favor of the amendment. Undoubtedly, many of these articles were written by Mrs. Chace, and they included extracts of letters from prominent leaders, both men and women; Harriet Beecher Stowe, Henry Ward Beecher, Philips Brooks, Henry W. Longfellow, Clara Barton, and many others who firmly believed that women should have the vote. In addition, one of Mrs. Chace's daughters, Mrs. "Lillie" Chace Wyman, wrote a long

article on the amendment which was published in two issues of *The Providence Journal*. Twenty thousand copies of this article were also printed and distributed among the towns of the state.

Although the articles in the *Journal* were clearly opposed to such a drastic change in the State Constitution, on the whole they were somewhat restrained. On the other hand, the attitude of *The Providence Evening Telegram* was not only antagonistic, but at times sneering and sarcastic. Once, the *Telegram* remarked; "Goodbye to domestic peace when Women's suffrage comes in. Any man who likes political strife well enough to want it for breakfast, dinner, and supper, and then take it to bed with him will vote for woman suffrage." About a week later this item appeared in the *Telegram;* "A chewing gum factory is to be established in Providence, probably in anticipation of the demand of women who will be sitting in the General Assembly, and at political meetings"[35]

In the end, however, all the labor during the month of March of the women devoted to winning the franchise for Rhode Island women was in vain. When the amendment was voted on, it was overwhelmingly defeated by a vote of 21,957 opposed against 6,889 in favor! This was a bitter blow, and Mrs. Chace must have taken the defeat to heart more deeply than her friends and co-workers. She was now over eighty years old and had dedicated herself for many years to securing what she believed was the fundamental right of women as citizens of Rhode Island. Nevertheless, the referendum demonstrated without question that the voters were opposed to women having this right, and this fact had to be accepted, unpleasant though it was. It was obvious that there was little or no hope of inducing the legislature to vote once more in favor of the political franchise for women. Consequently, it was decided to postpone indefinitely memorializing the legislature on the matter.

While the suffragists had pursued their original goal with unceasing vigor for many years, they had never lost sight of their secondary aim—the advancement of women in all areas. In the eighties they adopted a new objective—higher education of women in general, and in particular the acceptance of women as students by Brown University. This had been a debatable subject among the members of the faculty for some time. Some professors were in favor of this, and some were against it, while the members of the corporation seemed to prefer not to make a commitment one way or the other.

Mrs. Chace and Sarah E. Doyle, an associate in the suffrage association and a well-known school teacher, approached the subject earnestly. It was discussed over and over again at the general association meetings when plans were being made to convert the hesitant members of the faculty to their way of thinking.[36] Naturally, Mrs. Chace turned to her son, Arnold B. Chace, who was Treasurer of the Brown University Corporation for help. He willingly responded, but he could make little headway, because the problem involved not only the use of the classrooms, but the housing of women students, and few people, if any, in those days could envisage Brown as co-educational.

In 1889, E. Benjamin Andrews, the recently-elected president of the university and a broadminded man, set up a tentative plan of instruction for women which would lead to examinations and certificates of accomplishment. And three years later the door of opportunity for higher education of women swung wide open when the university corporation voted to make women eligible for both undergraduate and graduate degrees.[37] Mrs. Chace could congratulate herself once more for her part in building a brighter future for women. This success must have fortified her belief that "life devoted to human progress seemed really worth living."

After the Rhode Island Woman Suffrage Association was organized and Mrs. Chace assumed the duties as president, she concentrated much of her time and energy on its program, but she was also interested in many other activities. Naturally, her family came first. Although she could never forget the seven children she had lost by death, she felt lucky to have three children (two daughters and a son) who grew to adulthood. Her elder daughter, "Lillie," who was married to Mr. John G. Wyman, seemed closest to her because she shared her mother's interest in the Woman's Rights movement, but Mary, the youngest of them all, was tenderly loved. And Mrs. Chace was immensely proud of her son, Arnold Buffum Chace, who as a member of the faculty of Brown University and also as the treasurer of the corporation, played an active part in the college program. Later, four grandchildren, of whom one was named for her, were precious additions to the family group.

During her later years, she developed great skill in writing, and it was rare, indeed, that she did not have a manuscript in preparation, or an article for the press on her writing table. She always prepared at least one paper during the year for a meeting of the suffrage association, more likely than not on one of the many questions relative to the position of women in the civil and political life of Rhode Island. At one time she became absorbed in reading about the sufferings of Mary Dyer who had been exiled from Massachusetts Bay Colony because she was a Quaker, and who was later executed on the Boston Common. A fine portrait of the Quaker martyr was given at one of the association's meetings. In 1881, she wrote a long paper on the working conditions of women and girls employed in New England factories which she had been asked to present at a meeting of the Women's Congress in Buffalo. This also served as part of a program at one of the meetings of the suffrage association in Providence.[38]

She was greatly respected and admired in Rhode Island as an outstanding leader, and the press endorsed this sentiment. Articles and editorials that she sent for publication were accepted without question, and she wrote on all kinds of subjects. Like most strong-minded people, she had opinions on almost everything, and her articles mirrored her moral attitude on life in the nineteenth century. Her greatest concern was for the proper care and education of children to prepare them for their future, and also women's rights, but once in a while she would branch out into other fields, such as, for instance, descriptions of pleasant visits to Washington and Boston. She even ventured into the question of religious freedom, for which she adopted Roger Williams's phrase "Soul Liberty." In 1877 she advocated the wider use of Roger Williams Park on Sundays. "I pray you," she said, "open up more fields, plant more trees, invite more singing birds, put up more swings, launch more boats, run more horse-cars, encourage everything that is not wrong in itself, that will lure from the haunts of vice the boys and girls, the men and women of your city"[39] And it goes without saying that when she was fighting to get the legislature to vote for the state home and school, she more than once wrote to *The Providence Journal* in order to mold public opinion in favor of this project.

Summer was, perhaps, her favorite season, and she generally spent at least a few weeks somewhere along the shores of New England. In 1880, she built a cottage at Wianno on Cape Cod that became an unmitigated joy for many years. She loved the fresh sea air and the profusion of wild flowers around the house. She was invigorated by the sea bathing, and enjoyed watching the path of the sun as it crossed over the ocean. She soon had a circle of friends there, and one of the most enjoyable customs during her vacation were Sunday evening gatherings at her home which, like Topsy, "just

grew." The meetings were very informal, but a paper on a subject of general interest was read during the evening, or a discussion led by a particular person served as the program. These Sundays turned out to be the frosting on the cake of her Wianno summers, and were remembered during the winter months with nostalgic pleasure.

As she grew older, Mrs. Chace became an invalid, and eventually was confined to the second floor of her home. Her mind, however, was as clear and forceful as ever. She continued to write articles on a variety of subjects and was still deeply interested in the suffrage association, keeping track of its programs and activities by conducting committee meetings in her upstairs room. In 1895 it was decided to make another positive effort to get the amendment giving women the right to vote added to the Rhode Island Constitution. Mrs. Chace prepared an earnest memorial to the assembly about this much desired proposal.[40] By now she could point to Wyoming and Colorado as having granted full suffrage to women, and to Kansas which had conferred municipal suffrage on women. As in the years past, she repeated her fundamental plea for justice, but to no avail. As usual, the request was refused.

After she had served for twenty-five years as president of the Rhode Island Woman Suffrage Association, she felt that the time had come to resign, since she was by now eighty-nine years old. Her resignation, however, was not accepted, and she continued to occupy this position, in name at least, as long as she lived. When it became known that she had handed in her resignation, she received letters from all over the country expressing affection for her, and admiration for the years of care and thought she had given to the association, and her unceasing efforts to achieve its great goal. Her "wonderful ability, courage, and patience"; "Every good cause has had her support"; and "Mrs. Chace, the 'Bea-

con Light in Rhode Island'" were some of the tributes sent to her.[41]

It is sad, indeed, to have to relate that Elizabeth Buffum Chace did not live to see her dream of the right of Rhode Island women to vote come true. She died on December 12, 1899 at the age of ninety-three. Mrs. Chace was a remarkable woman having had, one might say, three separate careers. She was definitely a wife and mother who brought up her children according to the values she herself held fundamental for the good life —respect for all men and women, justice in all cases and for all humanity, and work for the betterment of the human race.

She had labored untiringly for the abolition of slavery, and after that evil had been done away with, she had continued to work for political and racial equality. Finally, she had striven to secure not only the franchise for women, but to broaden their participation on an equal basis with men in Rhode Island.

Her clear-cut mind led her to form clear-cut principles, and once these were adopted, she never gave them up. Serious-minded she was, perhaps to the point of grimness, but her nobility of character made her many friends, and her friends could count on the same loyalty and affection from her. Her portrait is best painted in a letter from a friend of long standing, the Reverend Frederic A. Hinckley. He said, "When my thoughts wander to the little company of earnest women in Rhode Island—always it is Elizabeth B. Chace who sits at the head of the table."[42]

Notes

1. Lillie B. Chace Wyman and Arthur C. Wyman, *Elizabeth Buffum Chace, 1806-1899,* I, 8.
2. *Ibid.,* II, 186.
3. *Ibid.,* I, 44.
4. James Truslow Adams, *New England in the Republic,* III, 401, 402.
5. *Ibid.,* p. 404.
6. *Ibid.,* p. 405.
7. Wyman, *Elizabeth B. Chace,* I, 52.
8. *Ibid.,* I, 33, 34.
9. *Ibid.,* II, 265.
10. *Ibid.,* I, 95.
11. *Ibid.,* I, 228.
12. *Ibid.,* I, 283, 284
13. *Ibid.,* II, 77.
14. *Ibid.,* I, 287.
15. *Ibid.,* I, 292.
16. *Providence Journal,* December 7, 1868.
17. Wyman, *Elizabeth B. Chace,* I, 311.
18. *Ibid.,* I, 320.
19. *Ibid.,* I, 342.
20. *Ibid.,* I, 329, 330.
21. *Ibid.,* II, 57.
22. Records of the Rhode Island Woman Suffrage Association, 1868-1899, State Archives, Rhode Island State House.
23. Elizabeth Buffum Chace's Scrapbook, Rare Book Division, John Hay Library.
24. *Op. cit.*
25. Wyman, *Elizabeth B. Chace,* II, 87.
26. *Public Laws of Rhode Island,* January 1882, Chapter 320, p. 52.
27. Wyman, *Elizabeth B. Chace,* II, 93.
28. *Ibid.,* II, 248.
29. *Ibid.,* II, 191.
30. *Op. cit.*
31. Rhode Island Constitution, 1842, Article XIII.
32. Wyman, *Elizabeth B. Chace,* II, 219
33. *Rhode Island Acts, Resolves and Reports,* LXXV, 173-75.
34. Rhode Island Woman Suffrage Association Records.
35. Chace Scrapbook.

36. Grace E. Hawk, *Pembroke College in Brown University, the First Seventy-Five Years*, p. 17.
37. Walter C. Bronson, *The History of Brown University, 1764-1914*, p. 454.
38. Rhode Island Woman Suffrage Association Records.
39. Wyman, *Elizabeth B. Chace*, II, 89, 90.
40. *Ibid.,* II, 300, 301.
41. *Ibid.,* II, 304.
42. *Ibid.,* II, 306.

Bibliography

Primary Material

The Providence Journal, 1868, 1877.

Public Laws of Rhode Island, 1882, Chapter 320.

Records of the Rhode Island Woman Suffrage Association, 1868-99. State Archives, Rhode Island State House.

Rhode Island Acts, Resolves and Reports. Vol. LXXV.

Scrapbook kept by Mrs. Chace. Rare Book Division, John Hay Library.

Scrapbook containing newspaper articles and editorials, March 1887. State Archives, Rhode Island State House.

Secondary Material

Adams, James Truslow. *New England in the Republic, 1776-1850.* Little, Brown & Company, 1926.

Bronson, Walter C. *The History of Brown University, 1764-1914.* Brown University Press, 1914.

Hawk, Grace E. *Pembroke College in Brown University, the First Seventy-Five Years, 1891-1966.* Brown University Press, 1967.

Wyman, Lillie Buffum Chace and Arthur Crawford Wyman. *Elizabeth Buffum Chace, 1806-1899: Her Life and Its Environment.* 2 vols. W. B. Clarke Company, 1914.

Conclusion

As we study these four "Portraits," we cannot fail to be impressed by many similarities. Three of these individuals lived in a different century, and each was born within the first decade of his or her century; Roger Williams in 1603, Stephen Hopkins in 1707, and Elizabeth Buffum Chace in 1806. In addition, each enjoyed almost the same span of years; Williams was eighty years old when he died; Hopkins was almost an octogenerian at the time of his death; Mrs. Chace lived to ninety-three years of age, and John Howland to ninety-seven. Each lived during times of great change, and each made great and lasting contributions to the welfare of Rhode Island and its citizens.

Each possessed strong convictions which never changed in spite of vicissitudes and pressures. While Roger Williams's gift of religious freedom gave him an everlasting place in the National Hall of Fame, let us not forget Stephen Hopkins's belief in the importance and feasibility of cooperation between the colonies, which was eventually translated into the union of the states under the Federal Constitution. Although the right to worship God as one pleases frees the human spirit, John Howland's legislation setting up free education for every child is equally important in freeing the human mind. And Elizabeth Buffum Chace's labors to place women on an equal plane with men in the life of the state, and her fight for the political franchise for women opened the door for all Rhode Island women in the twentieth century.

Let us forever be proud of these four Rhode Islanders and of their contributions to our state and indeed, to the western world.

Index

Adams, John, 49
Adams, John Quincy, 79
Adams, Samuel, 49
Albany Congress, First, 48
Albany Congress, Second, 49
American Philosophical Society, Hopkins elected member in, 45
Andrews, E. Benjamin, 109
Angell, Thomas, companion of Roger Williams, 7
Anthony, Susan B., the "First Lady" of Woman Suffrage, 106
Aquidneck, Settlement by Anne Hutchinson, 11
Articles of Confederation, 51
Awashonks, 21

Babcock, Colonel Henry, 41
Baptist Church, organized by Williams in 1638, 10
Barbary Pirates, 19
Barnard, Henry, 74
Barnhard, Mary, wife of Roger Williams, 4
Barton, Clara, 107
Baxter, Captain, 14
Beecher, Henry Ward, 107
Benefit Street, 36
Berkeley, Dean George, 78
Bicentennial Celebration of the arrival of Roger Williams in Rhode Island, 78
The Bloudy Tennant of Persecution for Cause of Conscience, 23
Board of Lady Visitors for State Institutions, 109; Mrs. Chace a member of, 109
Boundary disputes, between Massachusetts and Rhode Island, 16, 37, 38; between Connecticut and Rhode Island, 16
Brick Schoolhouse, 69
Bridgham, Samuel W., 79
Brooks, Phillips, 107
Brown brothers, 36, 69
Brown, John, 53, 93
Brown, Joseph, 45, 53
Brown, Moses, 36, 53
Brown, Nicholas, 36, 53

Brown University, awards honorary degree to Stephen Hopkins, 54; awards honorary degree to John Howland, 84; Hopkins first chancellor of, 45; members of Rhode Island Woman Suffrage Association labor to get women accepted as students to, 109

Buffum, Arnold, father of Elizabeth Buffum, 89; President of the New England Antislavery Society, 92

Buffum, Elizabeth, daughter of Arnold and Rebecca Buffum, 89, 113; marriage to Samuel Buffington Chace (1826), 90

Buffum, Rebecca, wife of Arnold Buffum, and mother of Elizabeth, 89

Burrill, James, 71

Cambridge University, 4

Canonicus, 7, 8, 17

Carlile, Mary, marriage to John Howland, 66

Chace, Arnold Buffum, son of Elizabeth Buffum Chace and Samuel Buffington Chace, 109, 110

Chace, Edward Gould, son of Elizabeth Chace and Samuel Buffington Chace, 98

Chace, Elizabeth Buffum. *See* Elizabeth Buffum.

Chace, Samuel Buffington Chace, 98

Chace, Samuel Oliver, Son of Elizabeth Buffum Chace and Samuel Buffington Chace, 95

Champlin, Christopher, 35, 63

Channing, William Ellery, 90

Charles II, 13, 14, 18

Charter of 1643, 11, 13

Charter of 1663, 14

Cheney, Mary, youngest child of Elizabeth Buffum Chace and Samuel Buffington Chace, 110

Child, Lydia Maria, 190

Clarke, Dr. John, 13, 14, 15

Clarke, John Innes, 71

Coddington, William, 11, 12, 13, 63, 78

Coggeshall, John, 12

Coke, Sir Edward, 3

Confirmatory deeds of 1659, 18

Continental Association, 48

Continental Congress, First (1774), 48

Continental Congress, Second (1775), 49

Continental Navy, 50

Crawford, John, 36

Crawford, William, 36

Cromwell, Oliver, 13

Davis, Paulina Wright, first President of the Rhode Island Woman Suffrage Association, 97, 98
Declaration of Independence, Hopkins a signer of, 51
Dexter, Gregory, 23
Douglass, Frederick, 96
Doyle, Miss Sarah, 109
Duddingston, Lieutenant, 64-65

Education, Howland's interest in free public schools, 68; labors to provide free education for Rhode Island children, 69-76
Emerson, Ralph Waldo, 90
Equal Rights Association, favors equal rights for Negroes and whites, 97
Essay on Trade, 44

Federal Constitution, celebration in Providence over Rhode Island's ratification of, 67; congratulatory address sent by Providence Association of Mechanics and Manufacturers to George Washington, 75; Howland writes thirteen toasts in honor of, 67-68
George Fox, Digged Out of His Burrowes, 20
Franklin, Benjamin, 40, 66
Franklin, James, 66
Friends' School (Moses Brown School), Elizabeth Buffum Chace a student in, 89

Garrison, William Lloyd, 91, 96
Garrison, William L., Jr., 106
H.M.S. Gaspee, Burned in 1772, 46, 64
Gladding, Benjamin, 64, 66
Gorton, Samuel, 11
Government of Providence, set up by Williams, 8
Great Swamp Fight (1675), 22
Greene, Albert G., 78
Grimké, The Misses, 92

Hamilton, Alexander, 75
Hannah, New York sloop, 3
Harper's Ferry, John Brown's raid on (1859), 93
Harris, William, 16-19
Healy, Martin F., 104
Higginson, Thomas Wentworth, 92
Hinckley, Frederic A., 113
Hopkins, Abigail, sister of Stephen, 33

Hopkins, Esek, brother of Stephen, 33; Commander of Continental Navy, 50
Hopkins, Hope, sister of Stephen, 33
Hopkins, John, brother of Stephen, 33
Hopkins, John, son of Stephen, 39
Hopkins, Rufus, brother of Stephen, 33
Hopkins, Rufus, son of Stephen, 36
Hopkins, Samuel, brother of Stephen, 33
Hopkins, Stephen, birth, 31; marriage to Sarah Scott, 33; marriage to Mrs. Anne Smith, 39; death of, 54; public services. *See* Appendix, 56.
Hopkins, Susanna, sister of Stephen, 33
Hopkins, Sylvanus, son of Stephen, 39
Hopkins, Thomas, great-grandfather of Stephen, 31
Hopkins, Major William, grandfather of Stephen, 31
Howe, Julia Ward, 100
Hutchinson, Anne, 10

Inscription on Hopkins Monument, North Burial Ground, Providence, 54
International Congress on the Prevention and Repression of Crime, 100

James I, 3
Johnson, Augustus, 64

Key into the Language of America, 22; importance of, 23
King Philip, sachem of the Wampanoag Indians, 21-22
King Philip's War, 22

Ladies' Antislavery Society in Fall River, Mrs. Chace First Vice-President, 91
Lee, Richard Henry, 51
The Liberator, 91
Library, in Providence, 39
Lincoln, Abraham, 93
Lindsey, Captain Benjamin, 65
Longfellow, Henry W., 90
Loudoun, Earl of, 43

Malbone, Godfrey, 35, 63
Manning, James, 45, 66, 69
Masham, Sir William, 4
Massachusetts Bay Colony, Roger Williams settles in, 4; Williams's dealings with, 5, 9
Maxcy, Jonathan, 72
Miantonomi, Sachem of the Narragansett Indians, 7, 8, 17, 79

Moffatt, Thomas, 64
Mott, Lucretia, 92

Narragansett Indians, friends of Williams and the Rhode Island settlers, 3, 4, 5, 6, 10
National Peace Movement, Mrs. Chace's interest in, 95
"The Neck," first settlement of Williams and the Rhode Island settlers, 8
Neighbors' Schools, 69
The New England Firebrand Quenched, 21
New England Woman Suffrage Association, 96
The Newport Mercury, 70
Nightingale, Colonel Joseph, 36
Nightingale, Samuel, Jr., 36

Oaklawn Home for Girls, 102
Old Stone Bank, founded (1819), 81
Oldham, John, 9

Pawtuxet lands, and claim of William Harris, 17-19
Pequot Indians, 9
Phillips, Wendell, 92
Pitman, John, 78
Poe, Edgar Allan, 96
Preamble to Education Law of 1800, 72
Proprietors' Schools, 69
Providence, burned in 1676, 22; settled in 1636, 7
Providence Association of Mechanics and Manufacturers, founded, 75; memorial sent to George Washington, 76; petitions Rhode Island General Assembly to establish a law providing free public schools, 70; protests against increased taxation of U.S. industries, 75; reports to Alexander Hamilton on condition of Rhode Island industries, 75
Providence Evening Telegram, 26, 27
The Providence Gazette, 44, 45, 70
Providence Journal, 96, 101, 103
"Providence Purchase," 7
Public Schools, law establishing free public schools in Rhode Island (1800), 71; schools set up, 73

Quakers, Mrs. Chace a member of, 89; resignation from, 93; settle in Newport (1652), 19

Randolph, Peyton, 48
Redwood, Abraham, 35, 63
Remonstrance. See, Essay on Trade, 44.

Revere, Paul, 82
Rhode Island, renounces allegiance to king, 50
Rhode Island Historical Society, founded (1822), 72
Rhode Island Reform School, Mrs. Chace's dissatisfaction with, 102
Rhode Island Regiment, Seventh Company, 65; Howland a member of, 65
Rhode Island Society for the Encouragement of Domestic Industry, 76
Rhode Island Woman Suffrage Association, founded (1868), 96-97; convention held at State House (1884), 105; and Brown University, 109; fights to amend Rhode Island Constitution, 107; suffrage amendment defeated, 107-108; later attempt to amend Rhode Island Constitution, 112
Rich, Robert, Earl of Warwick, 4
Richmond, Colonel William, 65
Rights of the Colonies Examined, 44, 45
Ripley, Dr. George, 90
Royal Commission, and boundary dispute between Massachusetts and Rhode Island, 38; appointed to investigate burning of *Gaspee,* 46, 47

Schools. *See* Public Schools.
Scott, Sarah, first wife of Stephen Hopkins, 33; death (1753), 39
Slavery, New England attitude toward, 90; petitions to Congress calling for abolition of, 91
Smith, Anne, second wife of Stephen Hopkins, 39; death, 53
Sockanosset, Home for Boys, 102
Stamp Act, violent reaction to in Newport, 64
Stanton, Mrs. Elizabeth Cady, 97, 106
State Board of Education, 104
State Home and School, organized for homeless children, 104
State Institutions, 99
Stowe, Harriet Beecher, 107
Sumner, Charles, 93

Temperance, Howland's interest in promoting, 81; Mrs. Chace interested in, 95
Thoreau, Henry D., 90
Tillinghast, Daniel, 36, 67
Tolman, James F. *See* Cheney, Mary.

Underground Railroad, Mr. and Mrs. Chace "members" of, 92

Valley Falls, evening schools for mill workers in, 94; Mrs. Chace organizes kindergarten in, 94; reading and recreation rooms open in, 94
Vane, Henry, 11

Wallace, Captain James, 65
Wanton, Gideon, 35
Wanton, John, 35
Wanton, Joseph, Governor of Rhode Island, 35
Ward, Samuel, 42, 48
Washington, George, 49, 53, 66
Webster, Daniel, 77
Weetamo, 21
West, Benjamin, 46
West India Trade, 35, 36
Whipple, Abigail, grandmother of Stephen Hopkins, 31
Whipple, John, great-grandfather of Hopkins, 31, 69
Whipple School, 69
Whitman, Sarah Helen, 96
Wickenden, Plain, grandmother of Hopkins, 32
Wilkinson, Joseph, uncle of Hopkins, 32, 34
Wilkinson, Lawrence, great-grandfather of Hopkins, 31
Wilkinson, Ruth, mother of Hopkins, 32
Wilkinson, Samuel, grandfather of Hopkins, 32
Williams, Providence, son of Roger Williams, 10
Williams, Roger, birth (1603), 3; marriage to Mary Barnhard, 4; death (1683), 25, 31
Women's Suffrage. *See* Rhode Island Woman Suffrage Association.
World Peace Movement, Howland's interest in, 80
Wyman, "Lillie" Chace, daughter of Elizabeth Buffum Chace and Samuel Buffington Chace, wife of Arthur C. Wyman, 107, 110